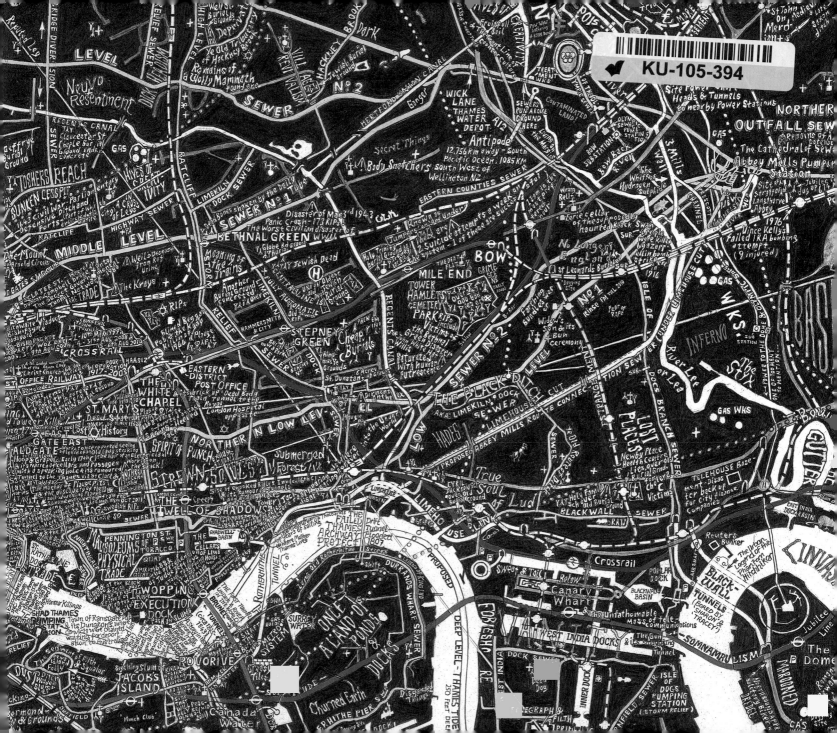

BTERRANEAN
LONDON

CRACKING THE CAPITAL

SUBTERRANEAN
LONDON

Dedicated to Matthew Power (1974–2014),
a fellow explorer who had a way with words.

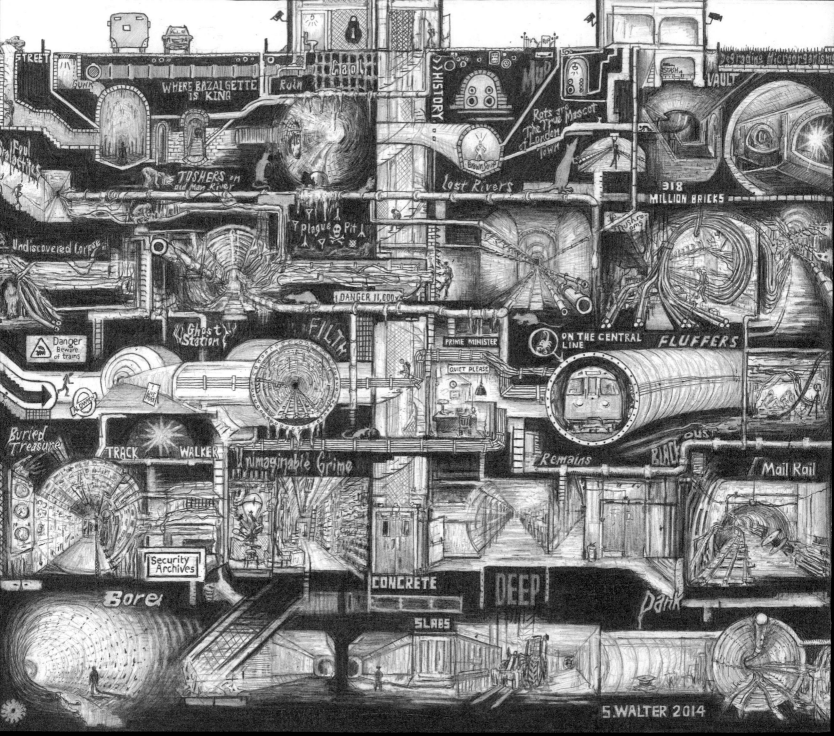

FOREWORD

I like to go up and I like to go down as well. I don't have either the physical courage or the devil-may-care brio of these place hackers, but I've been wandering around London, off-piste, for many years now. As a child in the north London suburbs I used to follow the long conduit the Mutton Brook took under the North Circular Road. Leaping from one chunk of masonry to the next islet of rubbish, listening to the continuous susurration of the traffic overhead, it was I who was transported. To be both in the city and yet outside of its established parameters is to experience a liberation from workaday concerns that are, almost always, shaped by wider economic imperatives. Our movements around the city are prescribed for us: we fit in, either willingly or unconsciously, with the great population flows as they flush through the tube system and the roadways. In our dreams we may all be anarchists, but in our actions, for the vast majority of the time, we're the most rigid of conformists.

A few years ago a young anthropologist friend who had the right key took me down a manhole in Brixton Water Lane and we walked for a mile or so through Bazalgette's sewer system to Clapham North. This was, I thought, the true chthonic underworld of London – its intense odour of comingled detergent and excrement a bizarrely appropriate crudescence of the city's superficial preoccupations: the denial of the bodily, and the reduction of its inhabitants to the status of soulless economic units. I spent at most an hour underground, but it was

long enough to be gripped by the strange architecture of the sewer system: its ironwork festooned with a dense mucilage of old toilet paper, its junctures echoic halls of coursing bath- and dish-water.

The locations that these explorers sought out in the course of producing these entrancing images are often dangerous to reach. The obstacles are physical, psychic and most importantly political. The contemporary city demands of us that we make obeisance to its superficial character – that we don't dig too deep. And the penalties for those who dare to enter the labyrinth can be severe. To use Debord's formulation: the Spectacle, while not confined solely to the visual, nonetheless requires a certain very restricted form of regard. To look under London is to catch the Old Lady of Threadneedle Street stepping out of her soiled underwear.

In his *Comments on the Society of the Spectacle* (1984) Debord wrote this: 'This perfect democracy fabricates its own inconceivable enemy, terrorism. It wants, actually, *to be judged by its enemies rather than by its results*. The history of terrorism is written by the State and it is thus instructive. The spectating populations must certainly never know everything about terrorism, but they must always know enough to convince them that, compared with terrorism, everything else seems rather acceptable, in any case more rational and democratic.' The inaccessibility of London's netherworld is a crucial component in our being convinced that 'everything

else seems rather acceptable': the punitive class-cleansing currently being enacted in London's so-called housing policy; the cannibalisation of the built environment by the ingurgitation of speculative trans-national capital flows; the elevation of grand and useless projects such as the Olympics to the status of 'sustainable' shibboleths – all this rests on a bedrock of carefully willed ignorance about what lies beneath.

In this book we are shown what we're not meant to see, and for that reason this text and its accompanying images have had to be wrested from the jaws of the state and its corporate allies by men and women who are, perforce, branded as irresponsible abetters of precisely that shadowy terrorism the Spectacle requires for its own perpetuation.

Do not be deceived: read the book – open the manhole.

WILL SELF
LONDON, 2014

Will Self is a London-based journalist and the author of nine novels. His most recent book, Umbrella, was published in April 2013.

INTRODUCTION

This book is an assemblage of material from 12 photographers infatuated with subterranean spaces. Over the course of five years, we infiltrated, by cover of night, underground layers of London, to capture the city's hidden depths. The tales of adventure and discovery behind those explorations are the thing of London legend, stories so lavish, so multiple, that we felt only imagery could render and relay the affective force of the experiences appropriately. What you now hold is the outcome of those efforts: the most comprehensive photographic account of subterranean London ever produced – every single photo taken without permission from anyone.

Fascination with the underground has always been fraught with fear. Recalling iconography connected to the River Styx, the Mayan Xibalba or the underworld in Dante's *Inferno*, the subterranean imaginary has long been associated with malice, disease, poverty, sin and death. People worked through these subterranean anxieties in two characteristic ways – by either fleeing from them or facing them. Londoners, in classic colonial style, chose to stand their ground, leading a 19th century secular assault on the seemingly malevolent forces of subterranea through stanch confidence in the vanquishing power of industrial technology. Citizens of this city, as a result, have always had a particularly poignant – and at times peculiar – fascination with underground spaces.

Fifteen decades have now passed since Sir Joseph Bazalgette, chief engineer of London's Metropolitan Board of Works, broke ground on the current London sewer system, just a few years before the world's first underground railway began to be dug out between Paddington and King's Cross. It was even further back

WHAT YOU NOW HOLD IS THE MOST COMPREHENSIVE PHOTOGRAPHIC ACCOUNT OF SUBTERRANEAN LONDON EVER PRODUCED – EVERY SINGLE PHOTO TAKEN WITHOUT PERMISSION FROM ANYONE.

in time when Marc Isambard Brunel, a French-born engineer, developed the tunnelling shield to burrow under the Thames, a technology that would transform future excavations ineradicably. Victorians, in clear admiration, toured newly constructed sewers, viaducts, tunnels and pumping stations, celebrating industrial urban development with utopian goggles on. Since then, countless subterranean spaces all over the world have been excavated using similar techniques. The sub-urban material infrastructures upon which our lives above now rely – electricity, water, gas, waste and data – passed inevitably from ubiquity to inaccessibility, a process of remythologisation of the underground. The goal of this book, in that context, is not to 'reconquer' these places or take them back from those forces that seek to keep them hidden, but to make transparent the emotional qualities of the underground that have caused such a contested, riven and complicated relationship to transpire. In short, we simply seek to add new elements to the mythological amalgam, yet another blip in a long history of subterranean happenings.

Today, if one were to take a large, hot knife and slide it through London, insert thumbs, and slowly peel it apart into two halves, it would become clear that the city exceeds its horizontal expanse in profile. Below us, hidden rivers and sewers, cable conduits, road and utility tunnels, train tubes, deep shelters and government citadels are hemmed in by disused, dysfunctional and forgotten features. Underneath this snarl, thousand-tonne tunnel-boring machines with names like 'Phyllis' and 'Sophia', Brunel's mutant offspring, are ripping through forty-metre-deep bedrock, inches at a time. While we sought to explore each of these layers in turn, we found difficulty in trying to piece together the scale of our spatial discoveries, to connect the shutter clicks outside the frame. Until we met Stephen Walter.

Stephen is an obsessive cartographer who, in 2012, was compelled to expel every memory he had of London subterranea onto a two-metre-wide piece of parchment. He then began an intensive period of research about other underground phenomena to pack into every inch of empty space on the map that led him, inexorably, to us. We could not imagine a better partner to have on this journey into the depths of the dug world. Like us, Stephen is a rogue archaeologist, excavating the past, present and future of the most vertical city on the planet on his own terms. Each of the five sections of this book will open with a cross-section drawing from Stephen, dredged from our mutual admiration for the underground.

TODAY, IF ONE WERE TO TAKE A LARGE, HOT KNIFE AND SLIDE IT THROUGH LONDON, INSERT THUMBS, AND SLOWLY PEEL IT APART INTO TWO HALVES, IT WOULD BECOME CLEAR THAT THE CITY EXCEEDS ITS HORIZONTAL EXPANSE IN PROFILE.

The acts involved in collecting, thinking through and even publishing this collection have been equally liberating and harrowing. Painfully, there are also at least another six people whose work is notably absent. They chose not to contribute for fear of the response of authorities,

11

given the nature of what we do. One, upon hearing we were publishing this book, stuffed four years' worth of negatives into a wheelbarrow in her garden and set it alight. To these other explorers, our colleagues and partners in grime, we take a bow, with respect to their accomplishments and camaraderie on these adventures and with respect, as well, to their decision to take shelter from corporations like Transport for London (TfL). In a letter dated 13 August 2013, TfL suggested we had 'illegally obtained information' and tried to stop publication of many of these photographs. A year prior, British Transport Police took down our front doors, came into our homes and confiscated our possessions. To the authorities who have done everything they could over the past few years to crush our spirits, for the spurious crime of being curious about our environment, we say this: *you will never silence us*. Because while you may control the truncheon, the battering ram and the water cannon, we control our desires and imaginations, and we need no more than that to cross these boundaries. We stand by our belief that publicly funded architectural projects should be visible and accessible to the hard-working public whose tax revenue made them possible in the first place. We also stand by our belief that play, curiosity and creativity are just as vital to the health of a city and its population as banking and business opportunities. Our photography, in that respect, is doing the dual political work of making urban places more open, more free, more transparent and more accessible. In other words,

our cameras are the more powerful weapons in a war over freedom of information, the actual motivation behind the war on terror.

Before sinking into a quagmire of political combat, let us re-centre ourselves by expanding upon desire and imagination and by turning back to you, the emancipated spectator. As you take the journey through these pages, we urge examination of both the representational and the affective power of these images. For, as they are assuredly documentation of places and events, they also work not just because we take time to figure out what they signify, but also because their pre-signifying characteristics are, we hope, felt in your own body as you flip through the pages. Further, the assemblage between explorer, camera and place, as you read this, is being reconstituted by your presence. In other words, this is now your project too. There is a potential here for a 'picturing' of relationships between body and environment that, often working beyond the intentionality of each photographer, asserts less the particularities and more the very possibility of inhabiting or occupying urban space beyond, beside and within forms presented to us for 'appropriate', 'safe' and even 'profitable' use. We would therefore embolden you not simply to passively enjoy the aesthetic resonances of particular moments of the past, but to inhabit them with us by considering yourself a part of this process of discovery and dissemination. Share this book, talk about it, help it do its work in the world. If our work inspires you to action, you will find us.

The book is organised into five layers. Flipping the page to section one, 'Water', you will be confronted by the beauty of Bazalgette's brick sewer system. We'll show you some of London's 'hidden rivers' and pass through some of its major junctions and flood chambers. In section two, 'Threads', we head into the city's shallow utility networks, hollow bridges and road tunnels, where many of London's non-vital fibre optic, telecommunications and gas networks rest. In section three, 'Transport', we explore the most dangerous explorations, those of the tube, to visit London's ghost stations, some of the most mythologised subterranean fragments of the city. In section four, 'Shelter', we will enter the city's deep sanctuaries, 30 metres below the street level, to see air raid shelters, secret government bunkers and the Mail Rail, a 6.5 mile system built in 1927 to transport post across the city on tiny trains called 'mini yorks'. In the final layer, 'Fresh Bore', we will begin to probe excavations that, due to 150 years of tunnelling, can only go deeper, 60 metres under the city. Photos of the Crossrail construction, new National Grid and new drain systems, updates on Victorian infrastructure, bring the book full circle.

This book is a testament to the achievements of a group of individuals who accomplished what no one in history ever has, the cracking open of the secret infrastructure of the world's ostensibly most secure city. But the book, we hope, will also become a historical document, reminding viewers long into the future of what London was, and what was possible here, at this point in time. Most importantly, though, we hope to make clear to everyone who journeys through these pages with us that adventure is not something happening in another place or another time; it's right here under our feet.

BRADLEY L. GARRETT, ET AL.
LONDON, 2014

Bradley L. Garrett is a researcher in geography at the University of Oxford. He is the author of Explore Everything: Place-Hacking the City.

IF OUR WORK INSPIRES YOU TO ACTION, YOU WILL FIND US.

WE SHALL NOT CEASE FROM EXPLORATION,
AND THE END OF ALL OUR EXPLORING
WILL BE TO ARRIVE WHERE WE STARTED
AND KNOW THE PLACE FOR THE FIRST TIME.
T. S. ELIOT

WATER

Walking at street level, one can easily neglect the ancient watercourses flowing beneath footfall. Yet these subterranean streams still ceaselessly rush, spill, fill and pour into and out of springs, reservoirs, storm drains, clay pipes, pumping stations and outfalls. The old churning channel names uttered aloud – *Tyburn, Fleet, Westbourne, Wandle, Neckinger, Effra* – invoke marginally familiar Victorian associations. The appellations are a hint, and there is another: every once in a while, an evanescent whiff from a lid or grate brings the subterranean flow to the mind's eye.

These rivers were once open, visible and even navigable, much like the Lea today. In one of the most radical urban overhauls of the 19th century, Sir Joseph Bazalgette was cleared to construct London's Main Drainage: 82 miles of new tunnels, designed to interconnect domestic liquid waste dumps into a new urban body, devised for interception and removal. Once functioning as intended, celebrated for the briefest of moments, the sewers were then physically and metaphorically buried, viewed only occasionally where city seams fractured, exposing glimpses of the underworld, prompting the telling of tall tales filled with giant rats, discarded murder weapons, bloated corpses and clandestine late-night conferences amongst criminals and creeps.

Our ambitions were simple. We wanted to see the hidden waters, to touch Bazalgette's bricks, to understand how the system worked, to disprove, verify or exacerbate the mythology of underground London. We began by sneaking into a portal to the system, Abbey Mills Pumping Station, the 'Cathedral of Shit', where human waste and water met delicate wrought iron, cogs, wheels, belts, pipes and electric pumps. All it took to get in was to send a skinny explorer shimmying up a gutter pipe to pop open an unlocked pane and wiggle in.

Tentative moves into the streets followed, where rolled-out maps were deployed under the lambent lights of quiet alleyways. Groups of explorers could be seen, night after night, in swishing hip-high fishing waders, head-torches strapped tightly, drain keys deployed with nervously clenched fists, hunting for metal manholes in pavements harbouring rungs down to old river channels. As lids were pulled back with a rusty crack, long-stuck soil plunged into darkness and thick waste-laced fumes of combined system liquid wafted past expanding pupils. Descending into the arches, better judgement left on the pavement above, explorers reached out, caressing hand-laid bricks, just a few of the 318 million in the system. As we stood in the flow of the River Fleet near Blackfriars, the imagination

inexorably stretched up the channel through King's Cross and Camden Town to bubbling sources in Hampstead and Highgate ponds. By the time the springs' gush cut past our feet, wedding wader PVC to skin and sock, it was a murky grey mess of floating turds, tampons and toilet paper, sometimes accumulating into little islands just solid enough to traverse.

In darkness, of course, vision gives way to sound. Beyond the ceaseless stridency of rushing waters, car tyres tantalisingly caused manholes to pop out of the tarmac, dozens per minute. When they crashed down, the reverberations would chase themselves through the old river channels into infinity. A particularly dramatic aural aberration was formed in the River Effra under Dulwich, where an angular ceiling came into contact with a slopping mass of grey sludge. Rain runoff and rising water levels pushed air bubbles from the goo. Vociferously popped by pressure against the grade, the sound of the bubble being ruptured echoed through the chamber, followed by a foul-smelling waft. The drainers in the party, explorers of wet waste, dubbed the place the Bog of Eternal Stench. More subtle sensual resonances also enticed. Waste-draped chains, catchments for more solid floating masses, dripped endlessly until a wadered toe kicked them back into the flow.

Periodically, in our tracing of river channels and storm drain interconnections, we stumbled into collection chambers, junctions and overflow reservoirs of seemingly impossible scale. These became gathering places away from the everyday hustle for quiet contemplation as well as meeting points for parties teeming with reckless abandon. The rivers of London are where we began unravelling the subterranean secrets of the city – where Victorian toshers, Thames Water flushers and foolhardy drainers throughout history have all found their own entrances into, and obsessions with, the London underworld.

WALKING AT STREET LEVEL, ONE CAN EASILY NEGLECT THE ANCIENT WATERCOURSES FLOWING BENEATH FOOTFALL.

▲ There are thousands of entrances to the sewers in London. We walk over many of them every day, with little thought as to what's contained within.

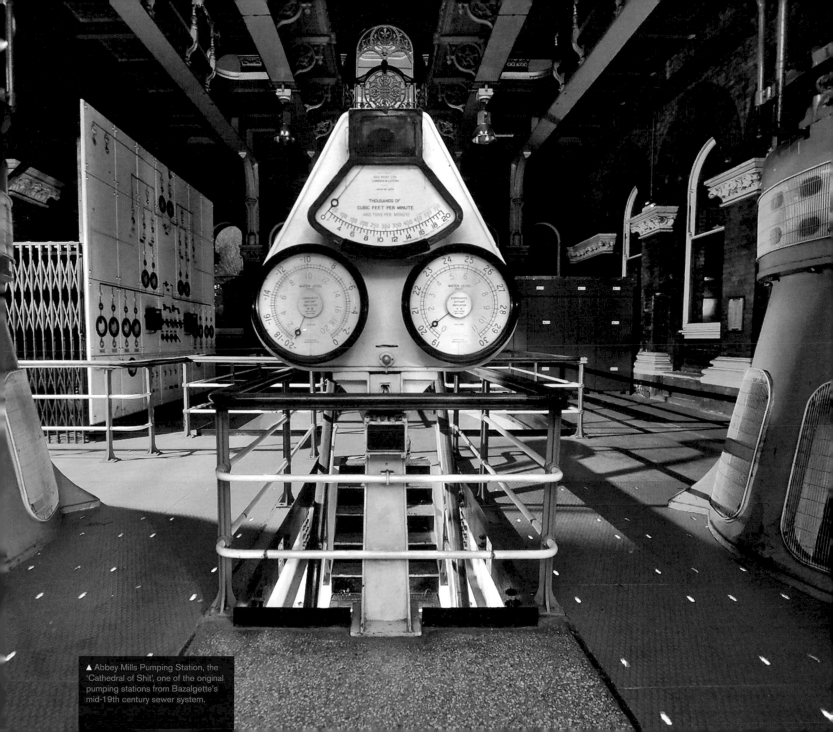

▲ Abbey Mills Pumping Station, the 'Cathedral of Shit', one of the original pumping stations from Bazalgette's mid-19th century sewer system.

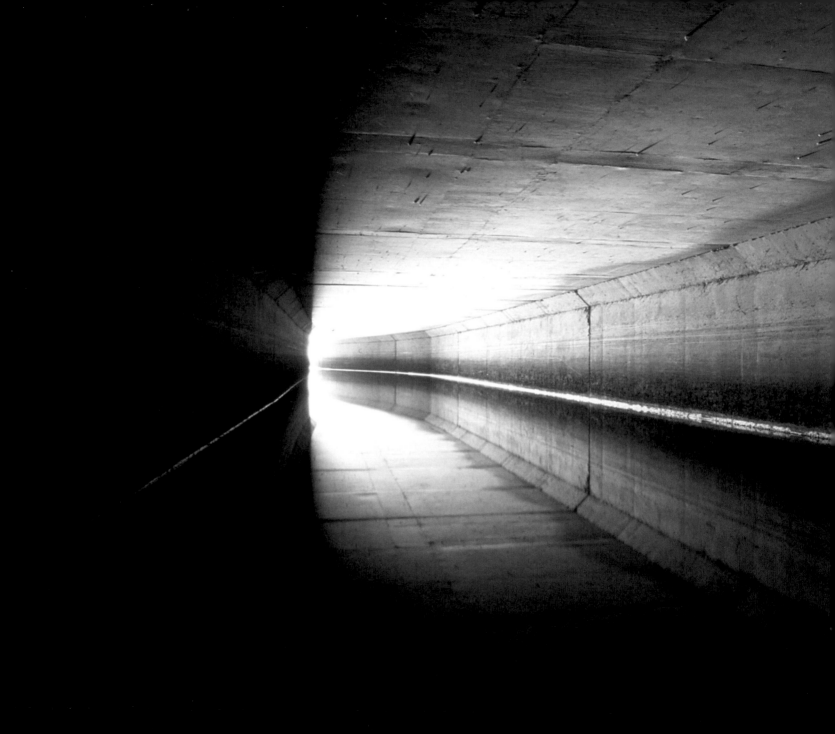

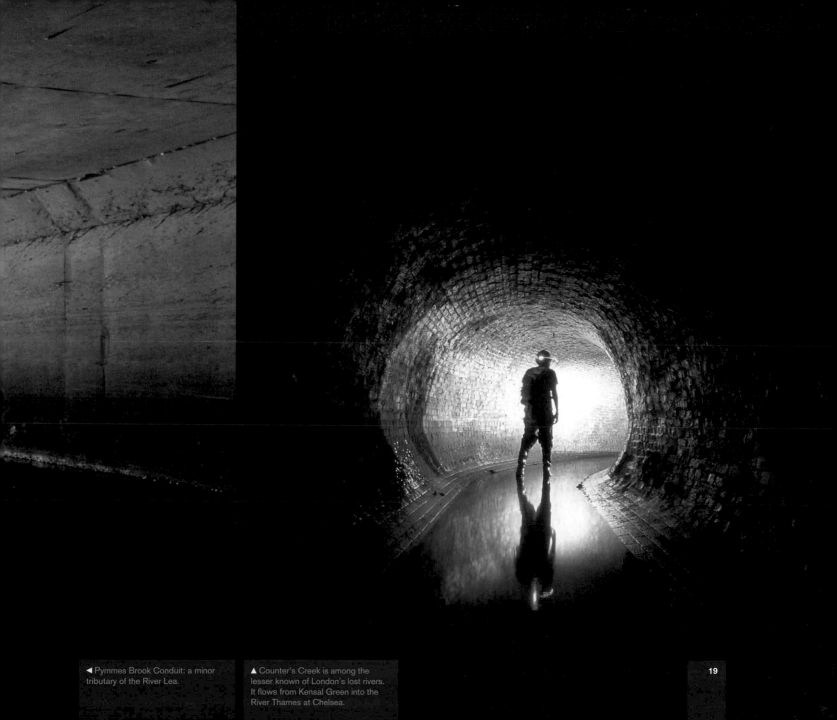

◄ Pymmes Brook Conduit: a minor tributary of the River Lea.

▲ Counter's Creek is among the lesser known of London's lost rivers. It flows from Kensal Green into the River Thames at Chelsea.

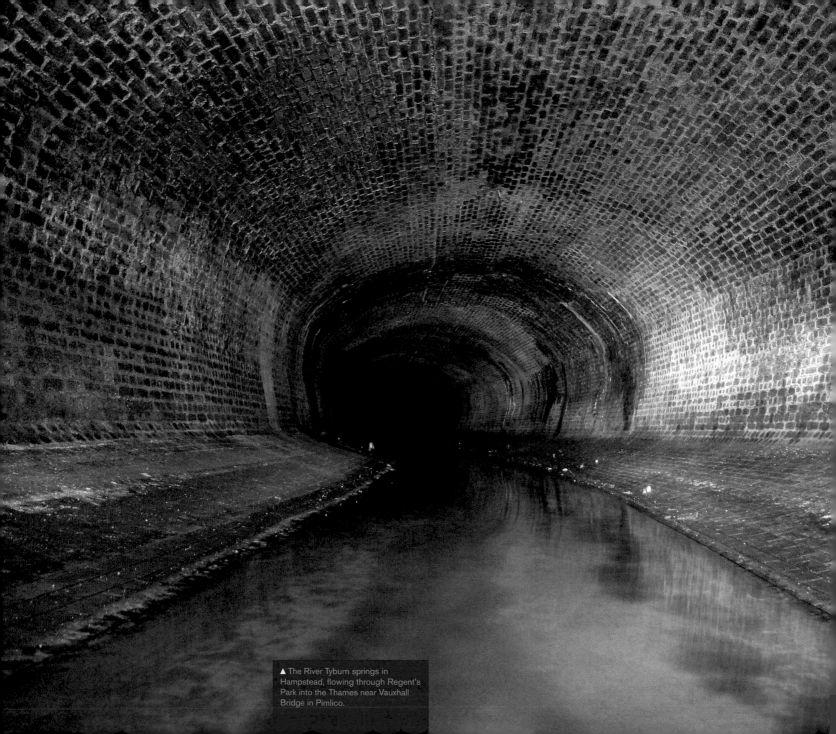

▲ The River Tyburn springs in Hampstead, flowing through Regent's Park into the Thames near Vauxhall Bridge in Pimlico.

OUR AMBITIONS WERE SIMPLE. WE WANTED TO SEE THE HIDDEN WATERS, TO TOUCH BAZALGETTE'S BRICKS, TO UNDERSTAND HOW THE SYSTEM WORKED, TO DISPROVE, VERIFY OR EXACERBATE THE MYTHOLOGY OF UNDERGROUND LONDON.

▲ It runs underneath some of the most exclusive residential areas in South West London.

▶ Moving through the river system often feels more like being drawn than being pushed. The ghosts of those hanged at Tyburn Gallows are said to wander the river by night.

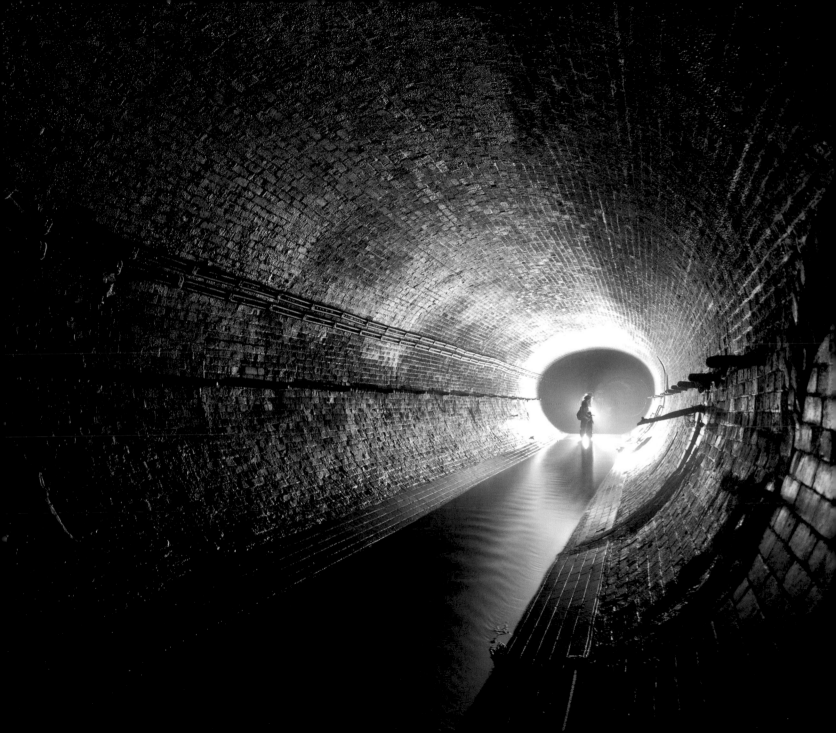

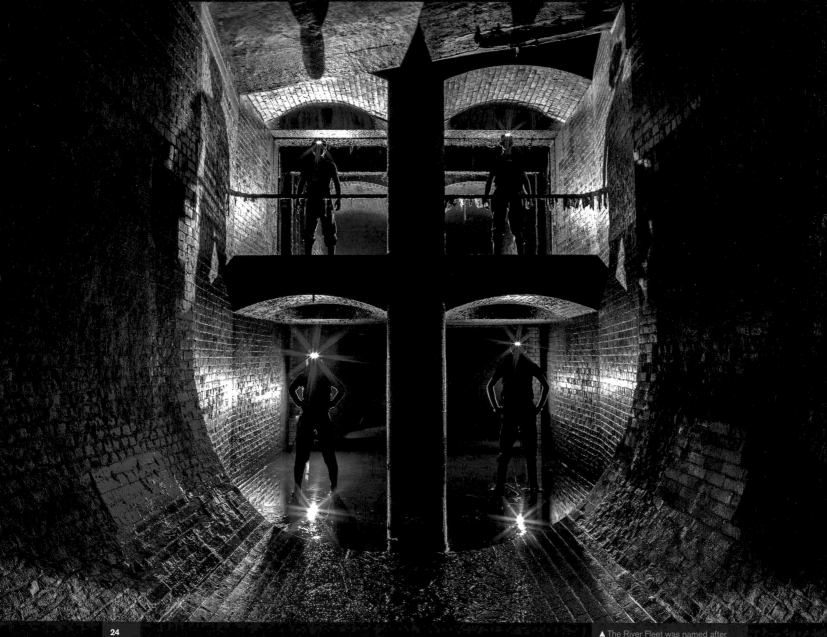

▲ The River Fleet was named after the Anglo-Saxon word *flēot*, meaning 'tidal inlet'. It served as a dock for shipping in Anglo-Saxon times.

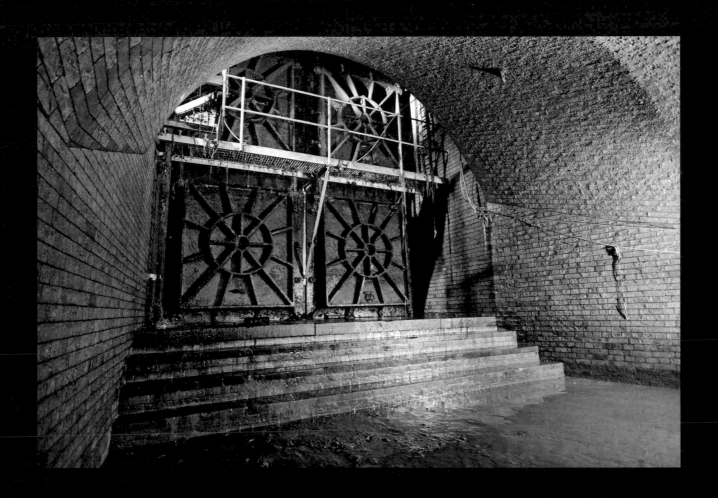

▲ The River Westbourne, one of London's best-known 'hidden rivers', flows from Hampstead Heath south through Hyde Park into the Thames.

► The River Effra. It was thought that a coffin found floating in the Thames in the Victorian era had been carried by the Effra from West Norwood Cemetery.

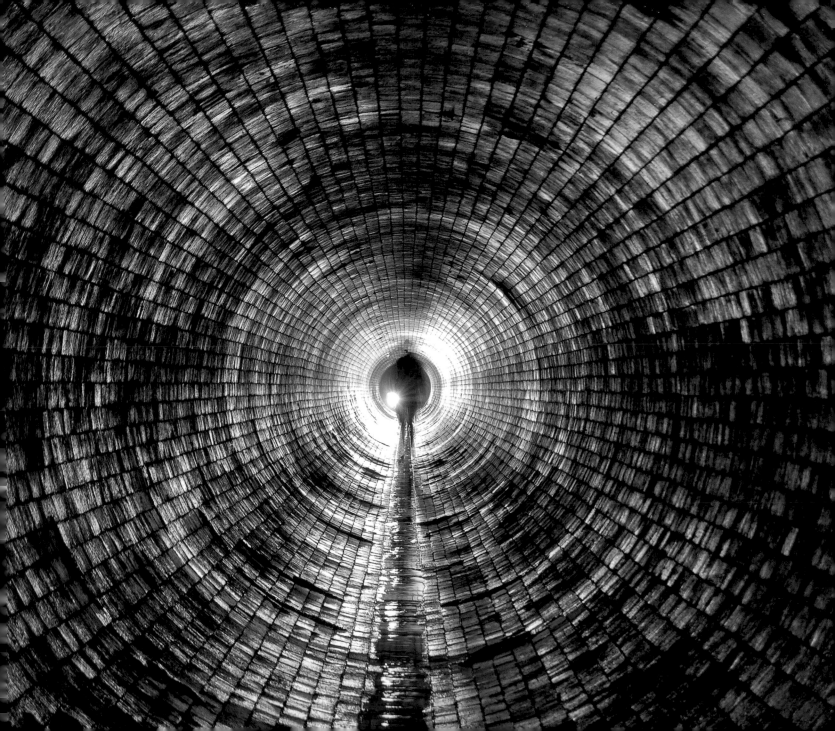

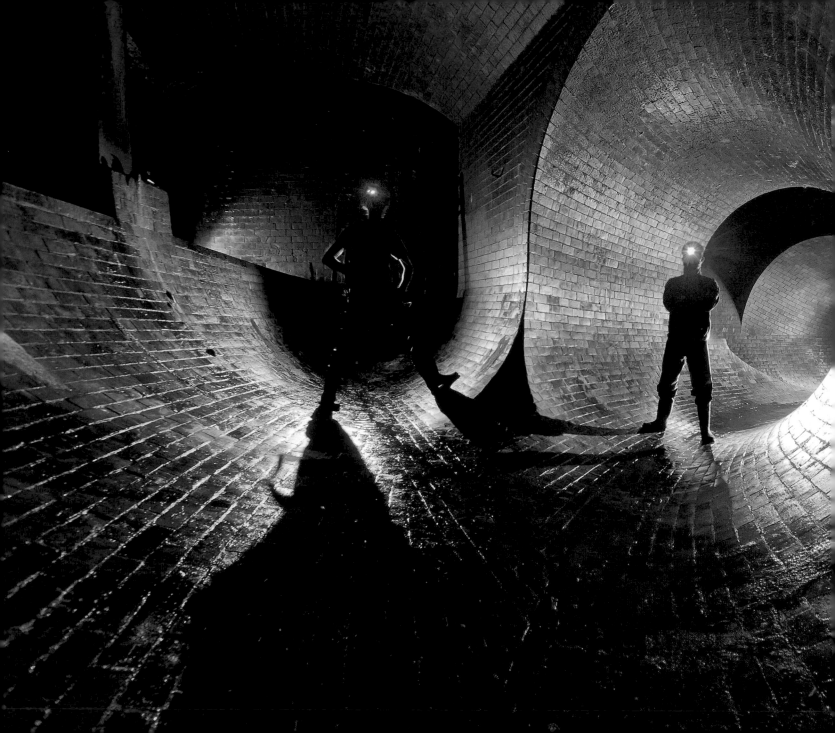

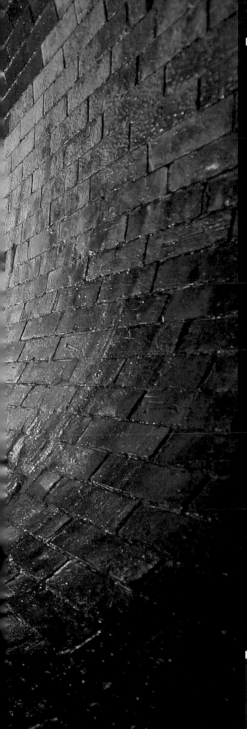

DESCENDING INTO THE ARCHES,
BETTER JUDGEMENT LEFT ON
THE PAVEMENT ABOVE,
EXPLORERS REACHED OUT,
CARESSING HAND-LAID BRICKS,
JUST A FEW OF THE
318 MILLION IN THE SYSTEM.

◄ Lucky Charms sewer junction
exemplifies the beauty of the
brickwork that makes London such
a drainer's paradise.

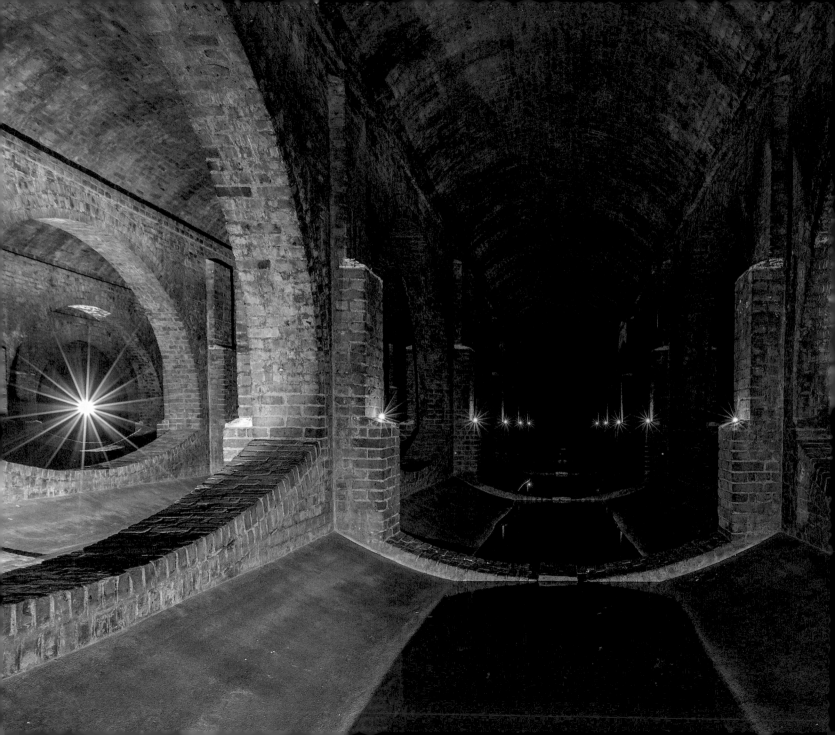

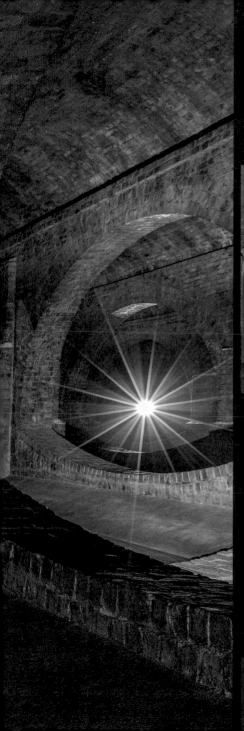

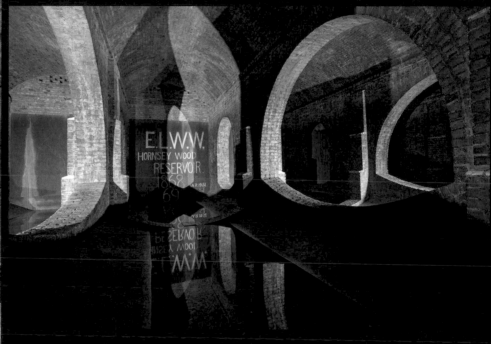

◄ Finsbury Park Reservoir, a massive, expansive overflow space underneath Finsbury Park, has been disused for many years.

▲ Finsbury Park Reservoir used to be known as the Hornsey Wood Reservoir, built by the no longer extant East London Water Works Company.

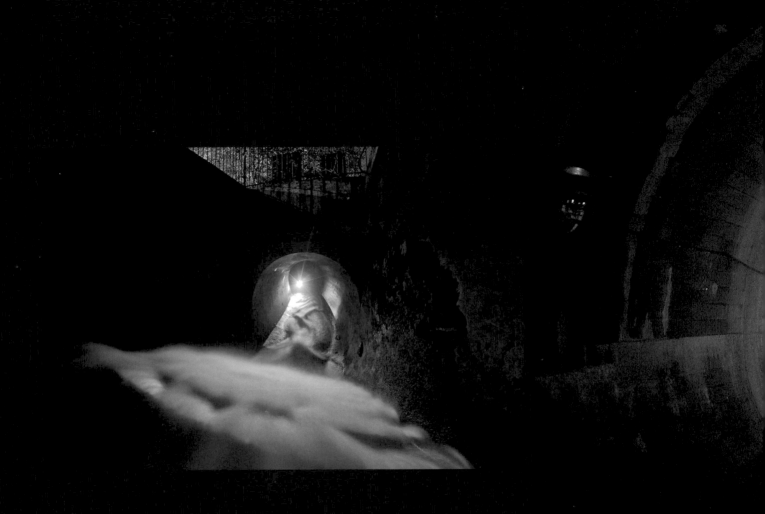

▲ A rare portal into the sewer system in Wandsworth.

▶ Ranelagh Sewer Overflow underneath Hyde Park, where the Serpentine overflow converges with a storm relief system.

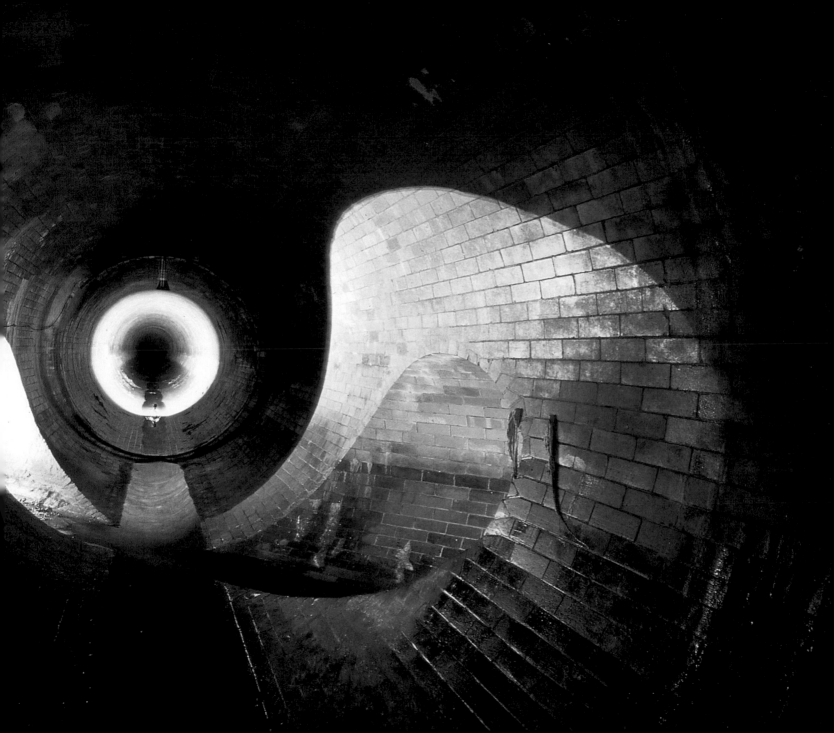

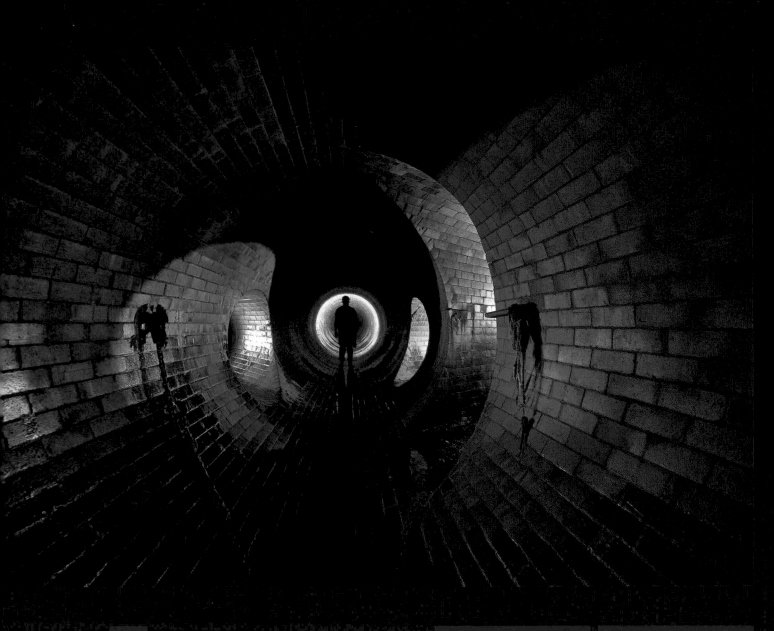

▲ The Rubix Junction is a legendary drainer destination.

► Miles upstream of Deptford, the 'hidden' River Ravensbourne runs through various culverts and is only partially lost.

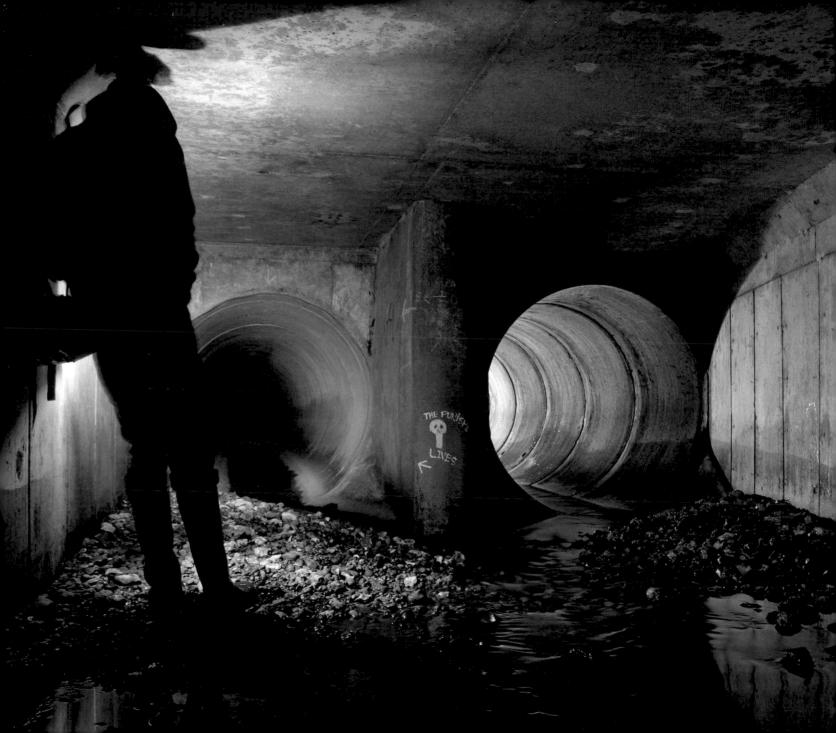

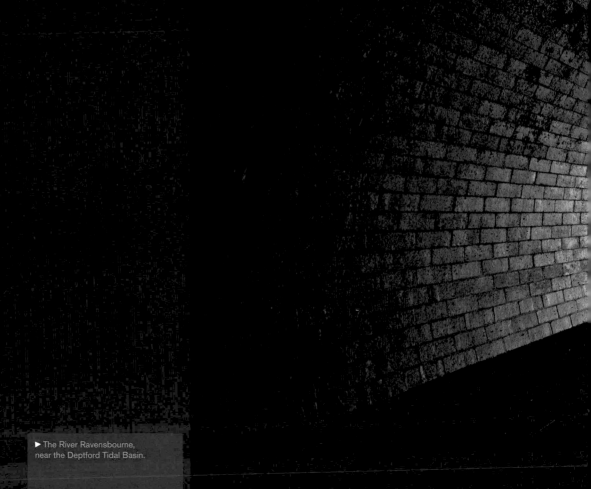

▶ The River Ravensbourne,
near the Deptford Tidal Basin.

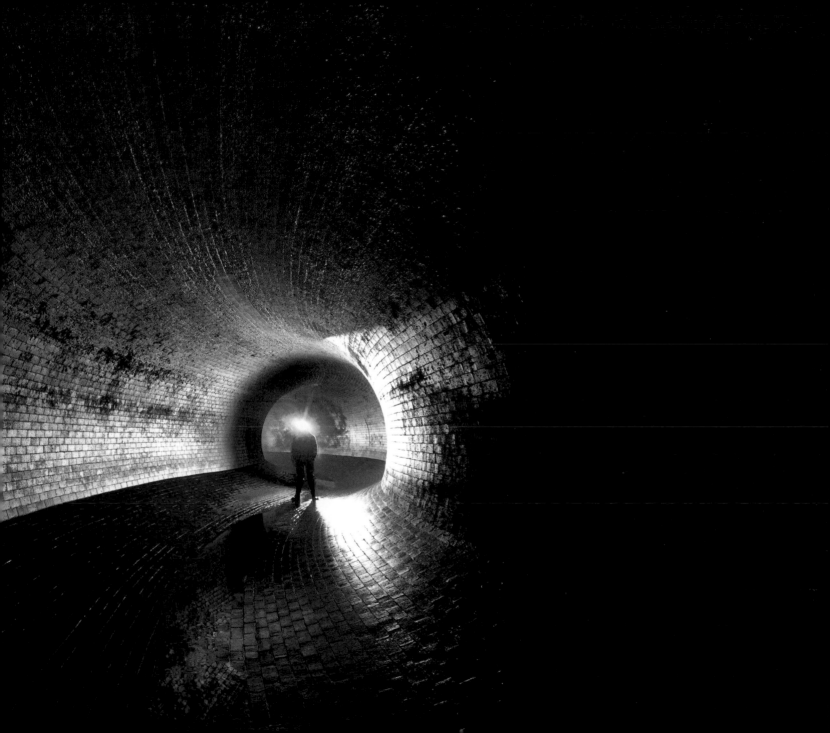

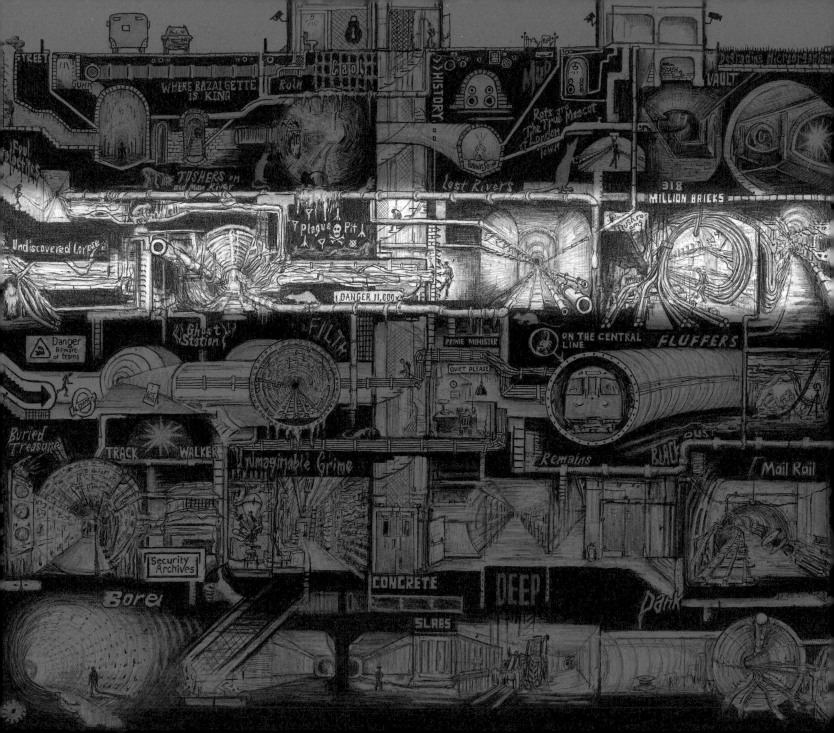

THREADS

London is a city of connections. While the sewers work ceaselessly to transport excrement out, adjoining tunnels delicately link architectures together. These channels, built after the passage of the 1893 Pipe Subway Act, are often entrenched just below vomit-dashed pavements, pondered through grills in the Rosebery Avenue traffic island during lunch-hour road crossings and post-theatre strolling on the wide corners of the Strand, where humming subsurface fluorescent tubes clue people in to the likelihood of secret verticality. Though their features vary vastly in form and function, these tunnels exist to preserve and protect the water, gas, power, telecommunications and broadband vital to contemporary metropolitan efficacy.

Like ribs around a heart, the urban body must protect its most fragile components carefully. Layers of security made entering these backstage sets a trickier endeavour than simply popping a lid on the street. We deployed mimicry, overt camouflage: high-visibility vests emblazoned with official-sounding names and hard hats. Bright orange cones were strategically placed on pedestrian pathways, complemented by reassuring smiles and a large set of keys jangled with authoritative boredom.

Cattycorner to Westminster tube station and Parliament, there is a statue of Boudicca on a plinth, an alluring patina sheen coaxed delicately from her by the elements. If you peek through a door in the plinth, ladder rungs betray the entrance to the Embankment itself. The 1.5 mile cable run swathes snaking sheaths of multi-coloured plastic, copper and fibre optics transmitting an endless stream of bank transactions, cat photos and pornography to myriad Londoners every day. The clusters of cables lounge languidly on long linear trays bolted to 19th century brick. Immediately underneath these threads, explosive gases float through a pipe shooting off into the darkness. Every junction looks much like the last, a messy tangle of fundamental arterial *stuff*.

In the tunnels, the cacophony of London was attenuated to dull drones and thuds periodically punctuated by screams in the night. Under the pavement, as we hid from streetlight rays penetrating pavement grills, high-heel click-clacks and countless conversations in unidentifiable languages and accents mingled with late-night laughter and yobs shouting random abuse. Every so often, a cigarette butt would be casually flicked through a grating into the tunnel next to a gas pipe and we'd stamp it out. This close to the surface, the city persistently imposed, even as our presence went unmarked. Until we popped the lid to leave, that is, violently rupturing a city seam. Dozens of people suddenly took note as we emerged with furtive smiles and nods all around, sealing the vein with a resonant thump, feet stamped and keys twisted, locks tugged once more for good measure before driving off. The eventfulness of the moment, for everyone involved, is a primary motivating factor for the expedition, the incessant yearning we all harbour to be a part of something happening.

We found similar concrete casks many metres below architectural landmarks. Underneath theatres, cinemas, galleries, kitchens and flats, we found a labyrinth of trapdoors, false walls, gantries and green-glaring emergency exits almost impossible to navigate, parts of which had been adapted into impromptu storage spaces for dusty corporate signage, archives of post-war reconstruction plans and panegyric tomes packed with jingoistic eulogy. The tunnels here also connect to the bases of the corporate towers, subterranean entries to London heights.

In the nether regions of bridges, we also found functionless hollow cavities. On London Bridge, just a few minutes' walk from the Shard, we popped a manhole looking for drains and instead found a space left over after planning – so we filled it with people, balloons, fireworks and a film projector: a temporary occupation of forgotten innards. Weeks later, walking a no-go pedestrian zone in a road tunnel, pushing on emergency exits, we instead found an entrance: a room full of ventilation solutions. These lattices and webs of utility are material legacies of known London acronyms: GPO, GLC, MBW, LCC and more. Visually challenging to decipher and typologise, they fill vital functions as much as any sewer – for every city is only the sum of its connecting threads.

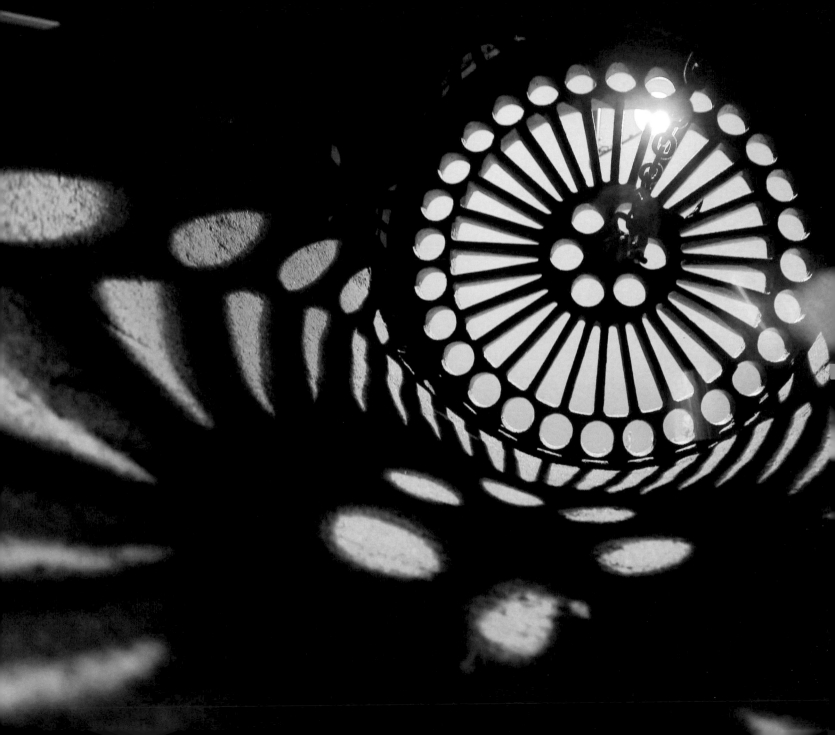

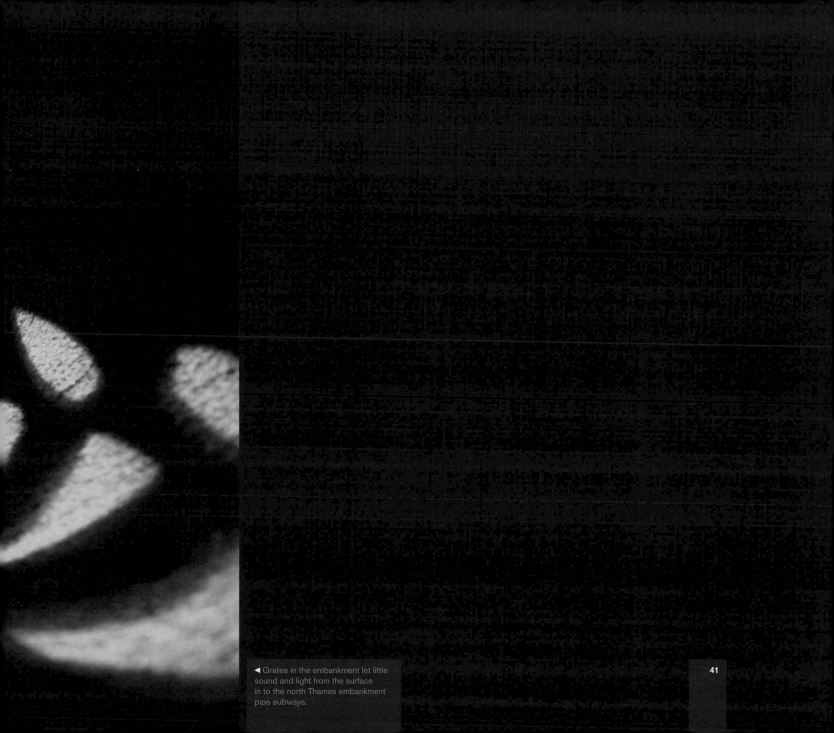

◀ Grates in the embankment let little
sound and light from the surface
in to the north Thames embankment
pipe subways.

◄ The tunnels are full of electric hazards, and other hazards less obvious.

◄ Communication threads include telecommunications, power and fibre optics.

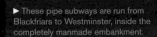

► These pipe subways are run from Blackfriars to Westminster, inside the completely manmade embankment.

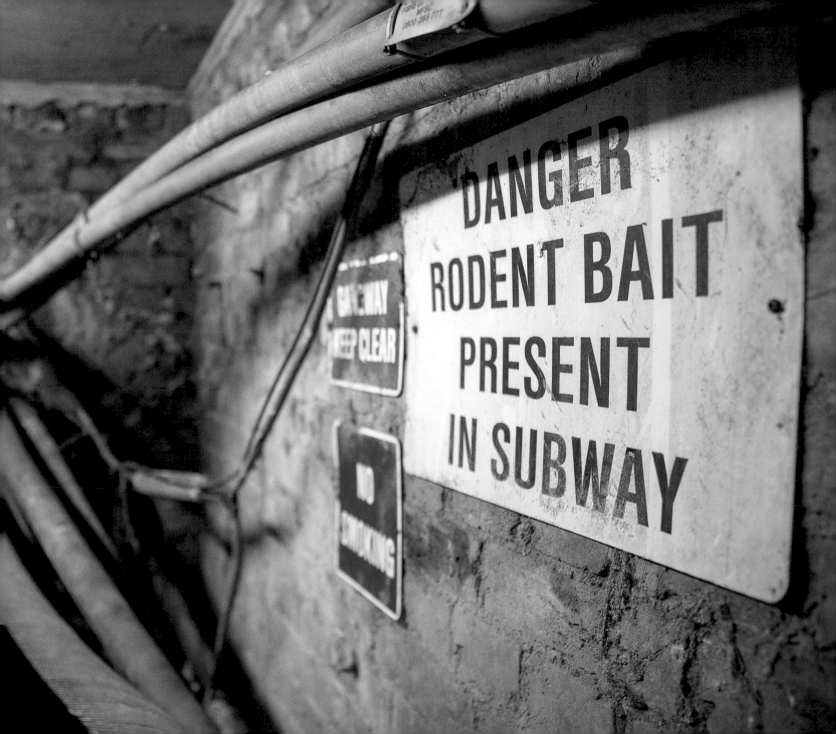

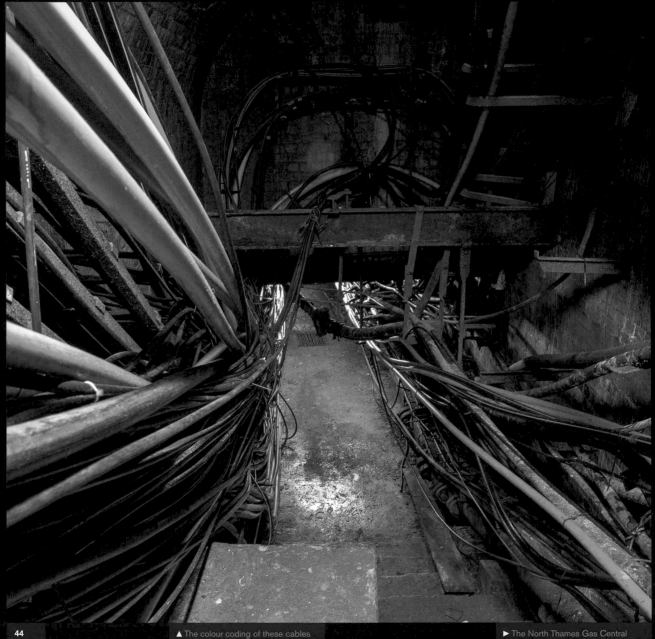

▲ The colour coding of these cables and ducts delighted us, and offered bright relief from the dank and drab surroundings in these riverside sections.

▶ The North Thames Gas Central Area tunnels in the City of London.

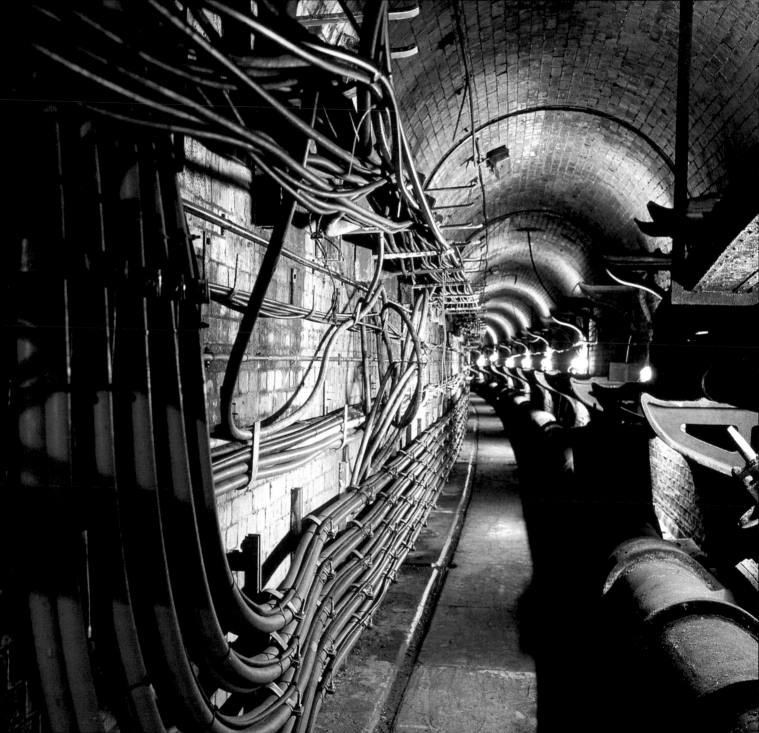

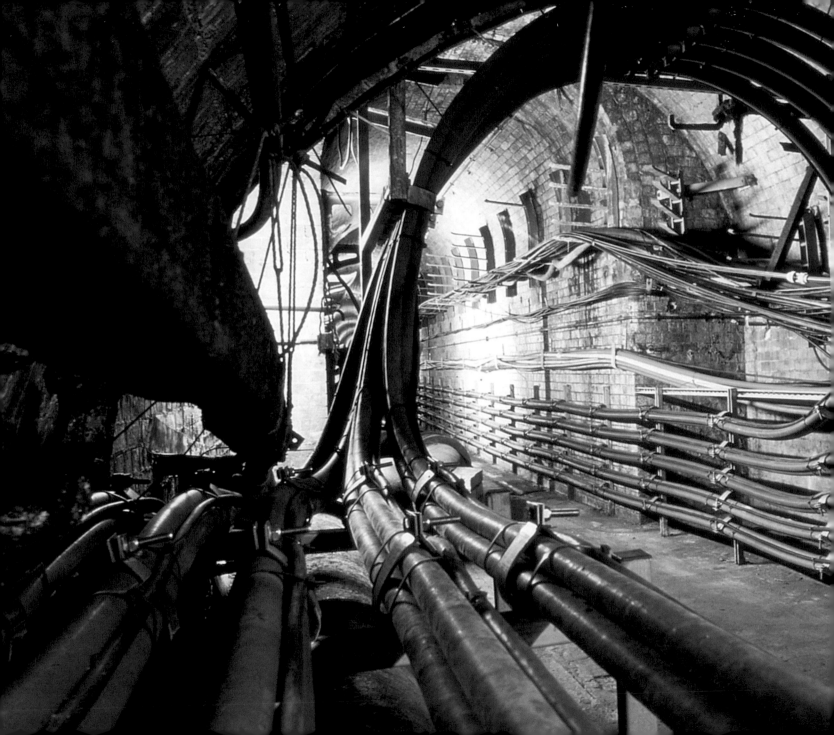

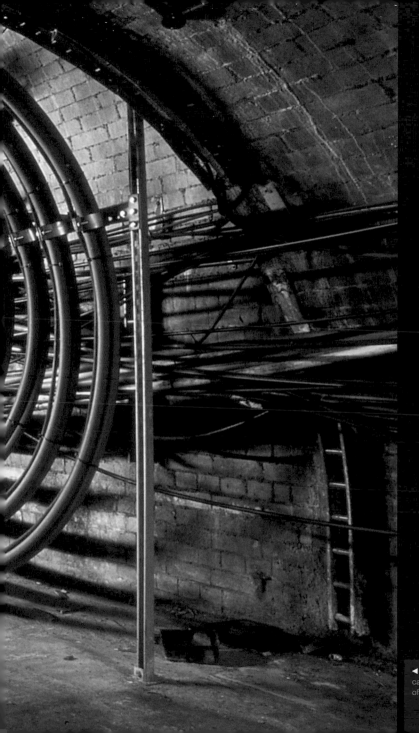

◄ A loop-de-loop of trunking carries cables around the characteristic form of a Victorian bricked arch.

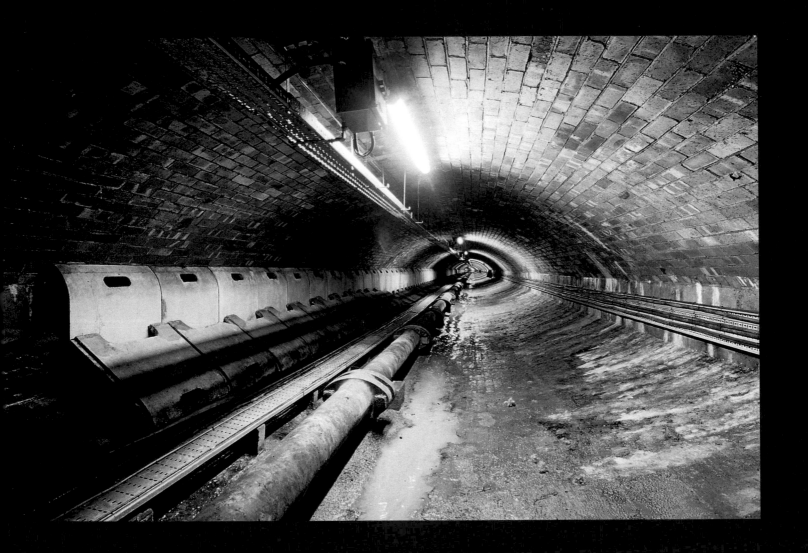

▲ Although this major London road tunnel is straight and comparatively featureless in form, this was more than compensated for by the beautiful interplay of lighting and brickwork.

▶ This is the service area of this major London road tunnel.

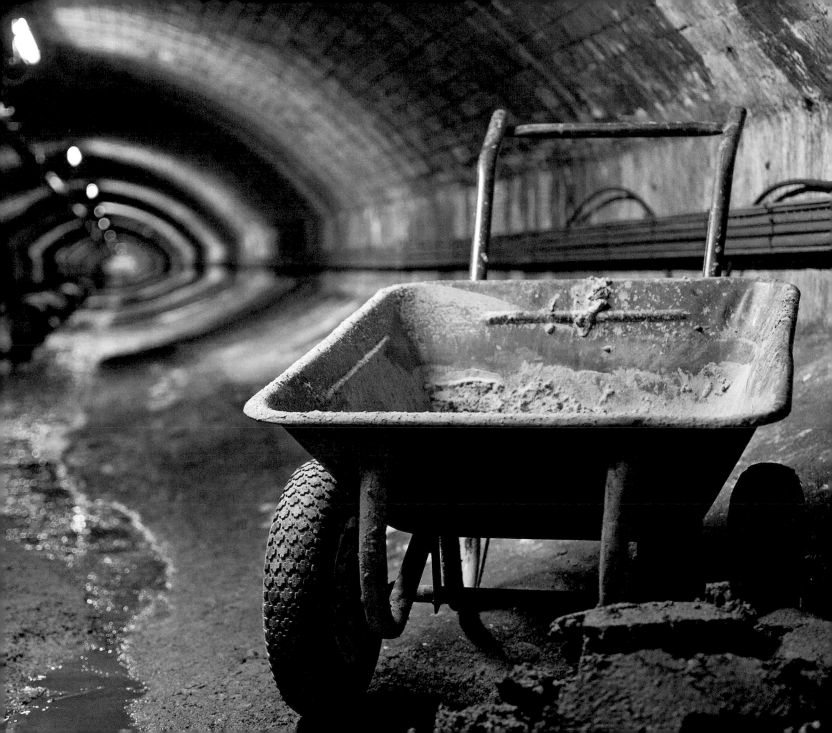

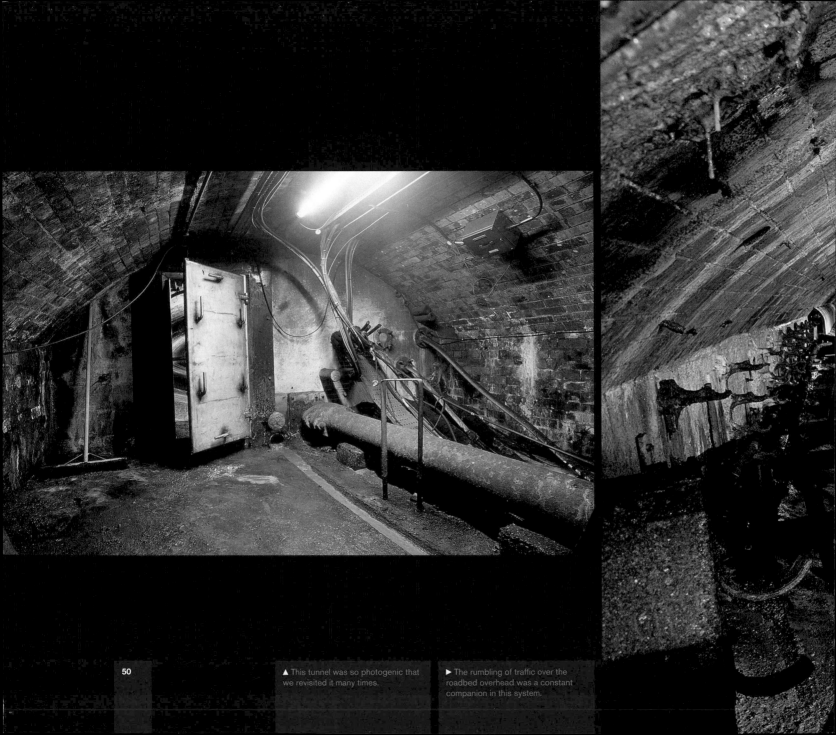

▲ This tunnel was so photogenic that we revisited it many times.

▶ The rumbling of traffic over the roadbed overhead was a constant companion in this system.

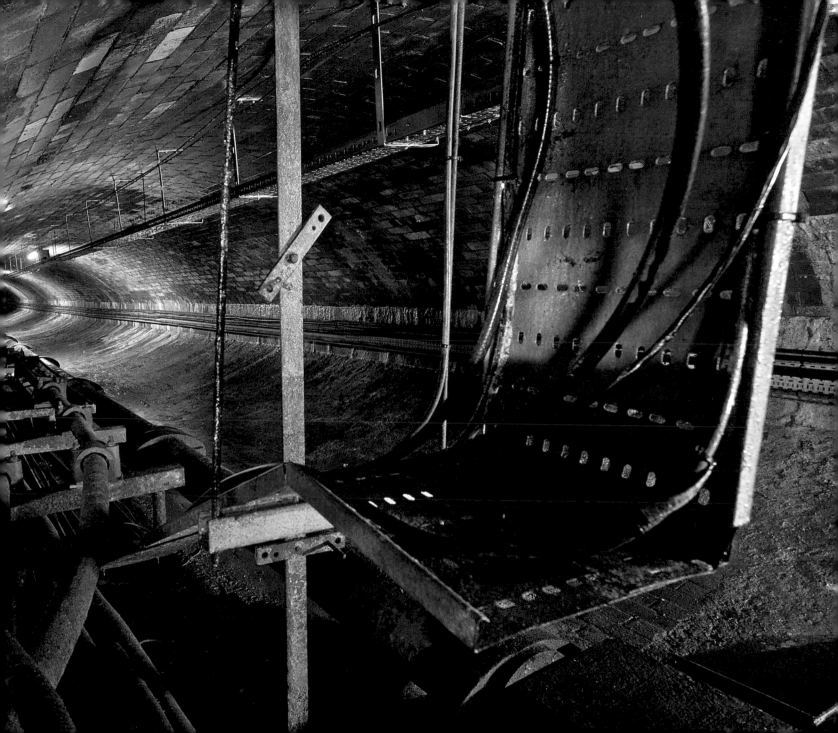

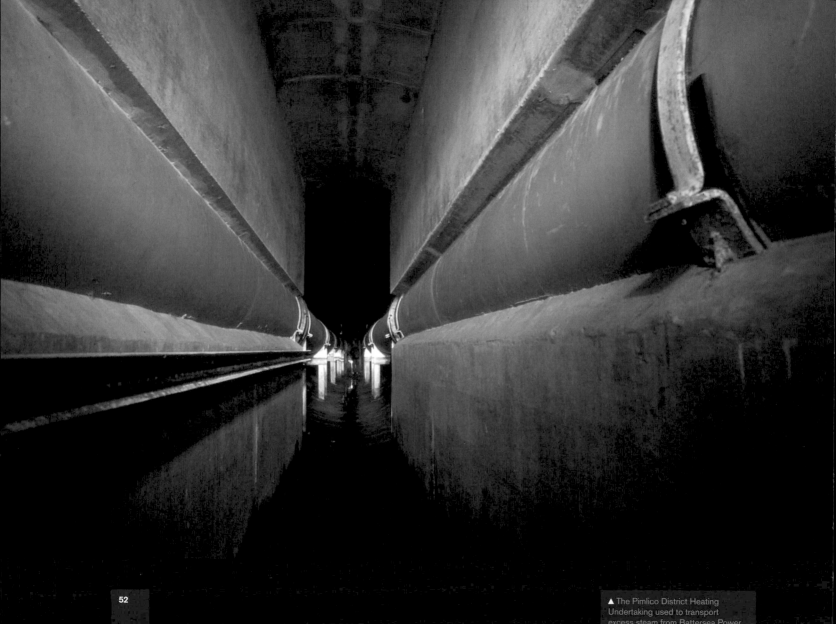

▲ The Pimlico District Heating
Undertaking used to transport
excess steam from Battersea Power

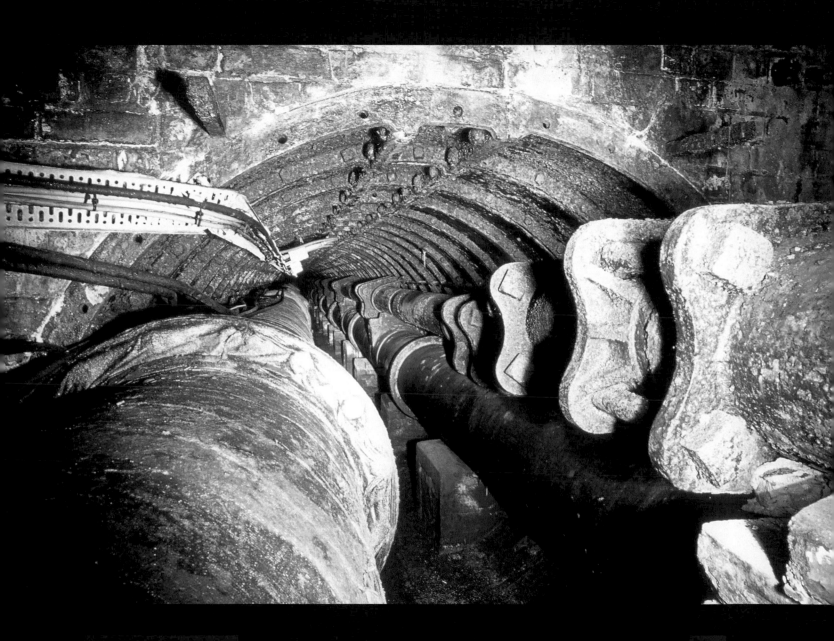

▲ The Tower Subway was first a cable-train subway, then a popular pedestrian subway. It was then a hydroelectric power network and now houses telecommunication cables.

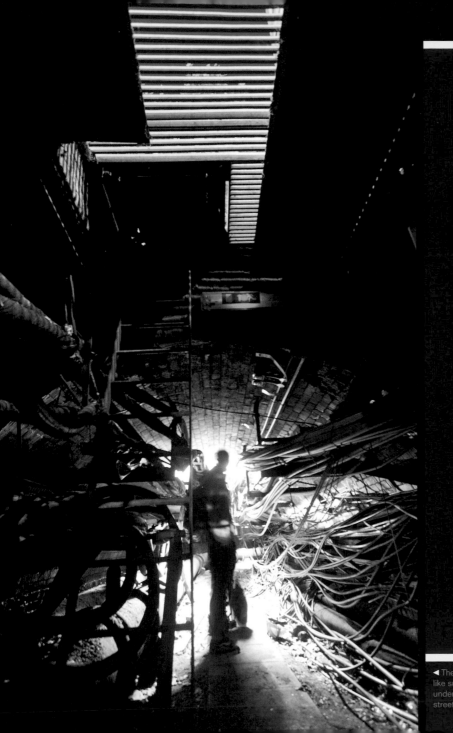

EVERY JUNCTION
LOOKS MUCH LIKE
THE LAST,
A MESSY TANGLE OF
FUNDAMENTAL
ARTERIAL STUFF.

◄ The pipe subways of London are
like subterranean streets running
underneath and contiguous to the
streets above.

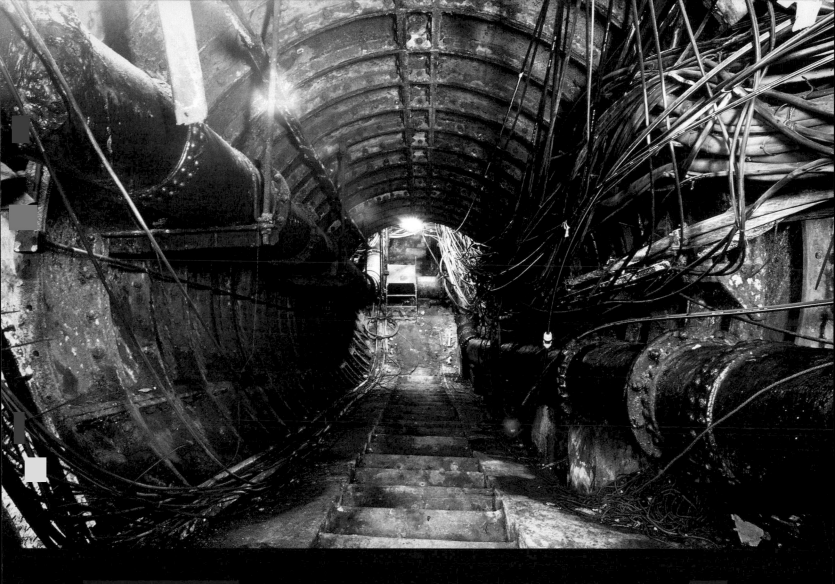

▲ This maze of utility tunnels connects a number of different systems and is marked by exceptional variation in its forms.

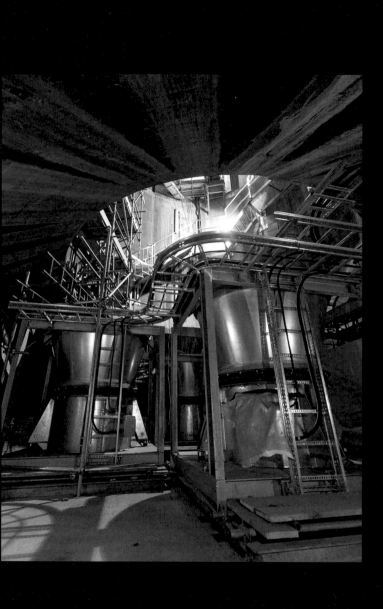

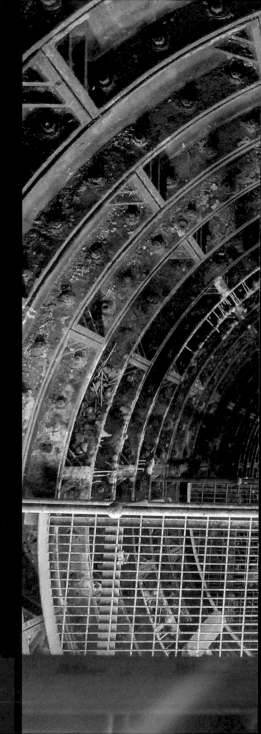

▲ Inside the Blackwall Tunnel, open
space remains where a ventilation
plant was constructed.

▶ One of two giant utility tunnels
stretching out under the Thames
from Battersea Power Station.

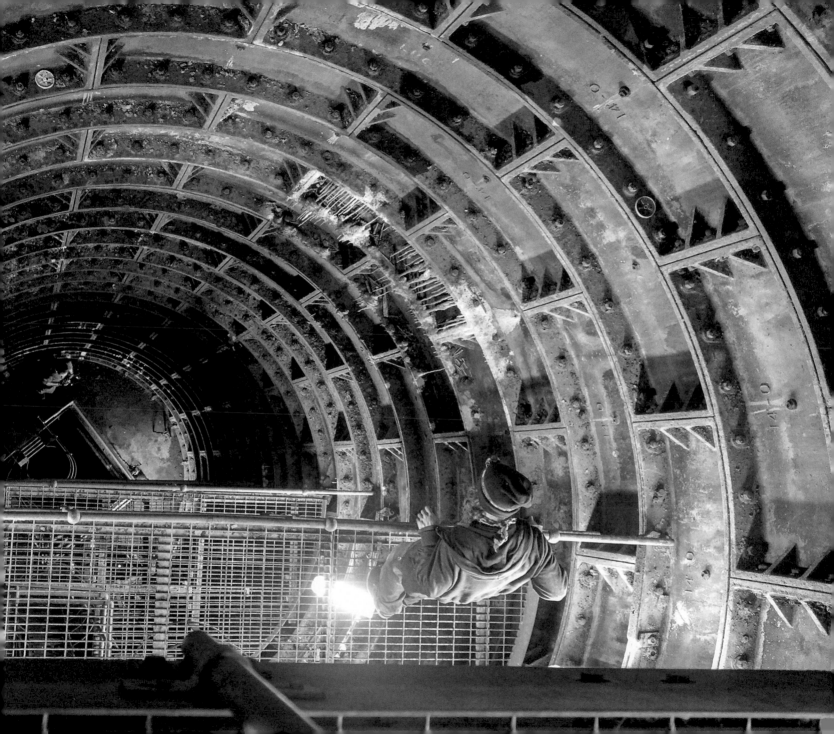

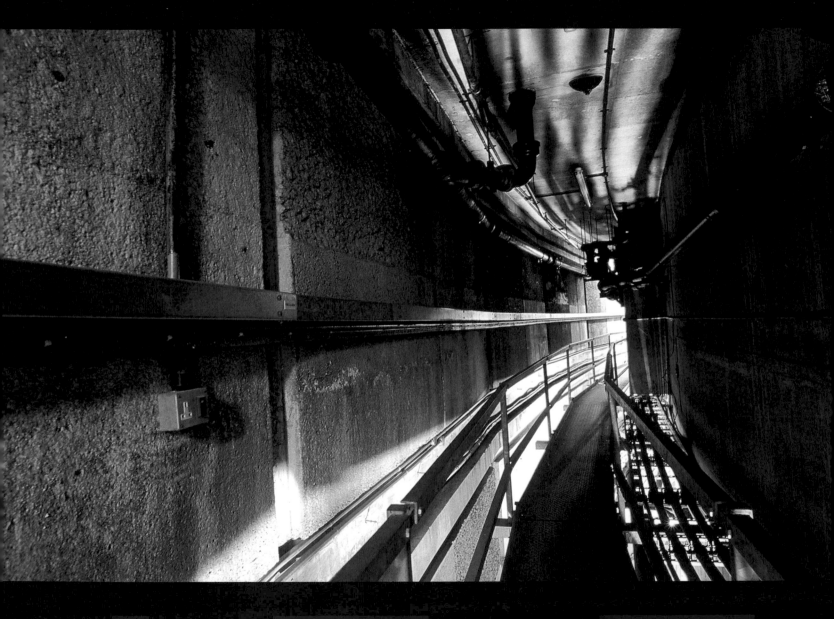

▲ Underneath a housing estate,
a vast sprawl of utility tunnels
stretches for miles.

► Carrying various utilities, these
tunnels form a literal and substantive
foundation for the dwelling places of
the housing estate above.

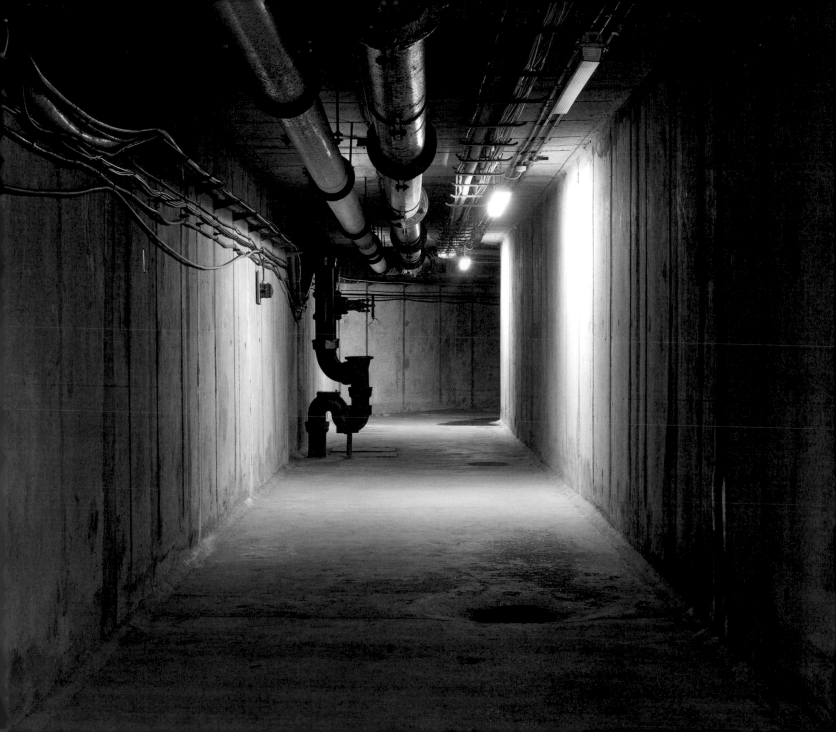

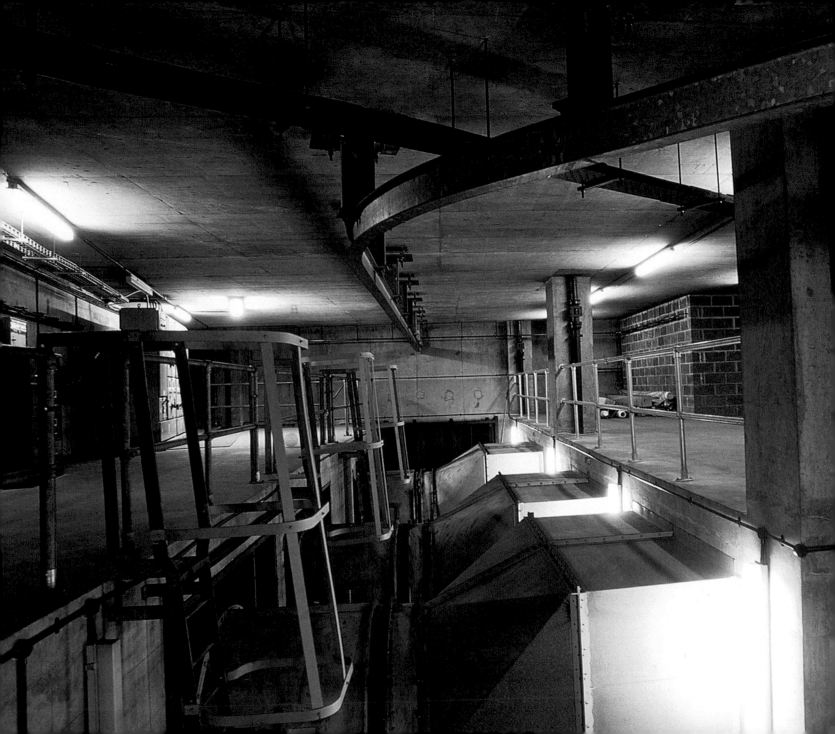

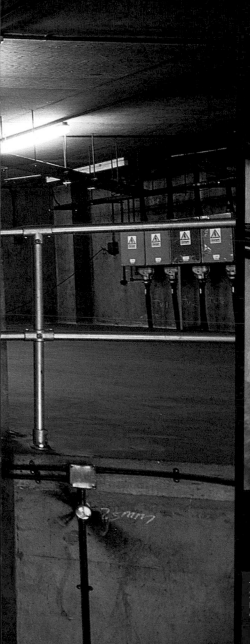

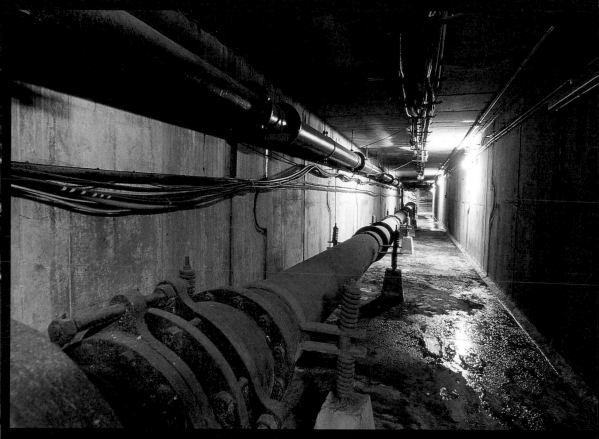

◄ The Lower Thames Street Tunnel, yet another space left over after planning, was turned into a control centre.

▲ The tunnels twist and turn through various junctures, and continue for kilometres underground.

THESE TUNNELS EXIST
TO PRESERVE AND PROTECT THE WATER,
GAS, POWER, TELECOMMUNICATIONS
AND BROADBAND VITAL TO CONTEMPORARY
METROPOLITAN EFFICACY.

► Inside the hollow cavity of
London Bridge.

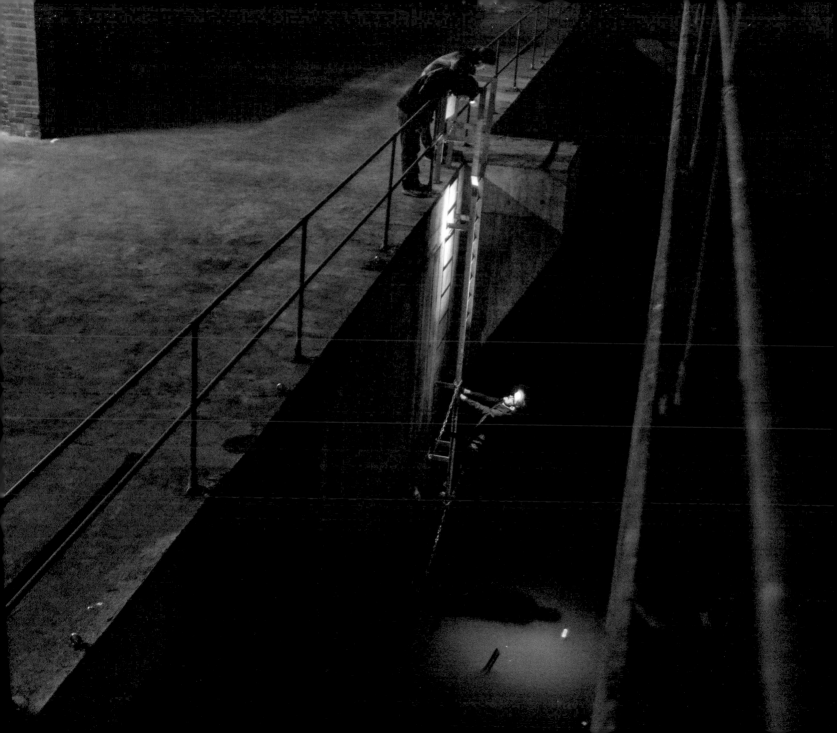

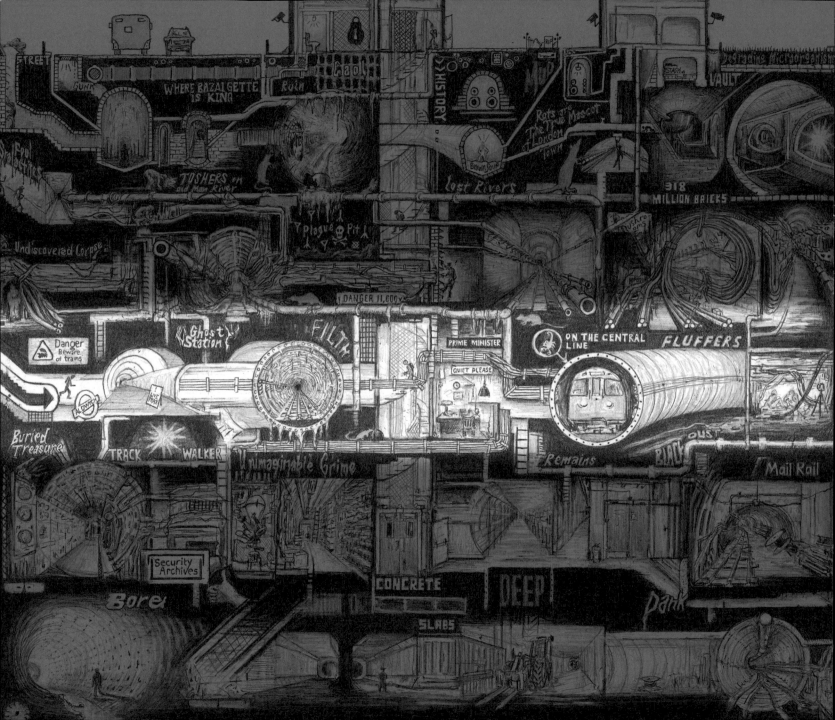

TRANSPORT

London is a city of movement. The sprawling radial that keeps bodies mobile, the first in the world, contains 120 miles of underground track. The system is riven with failures, omissions, errors and reworkings. Rusted out, broken and neglected bits are pressure points where unlocked and malfunctioning doors, open ventilation shafts and temporary scaffoldings provide opportunities to enter tunnel mazes and coax spatial secrets. But without nodes in the system to reach, one is quickly overwhelmed by the sheer variety of possible pathways.

A scouring of pre-war tube maps, post-war rebuilding plans, track diagrams and books revealed fragmented information about a contorted series of ownership changes in lines over 150 years, creating 'ghost stations', pockets of forgotten transit space. Some stations had been knocked down, retrofitted or just left to rot. Others were built too close together, rendering them underused or never used at all. Some had more dramatic endings: St Mary's was levelled by a German air raid in 1941 – no surface structures remained. Some, like Marlborough Road and British Museum, no longer had platforms. At Holborn and Charing Cross, some areas were live and others derelict. Debates ensued and decisions were made. Soon after, freshly minted plans in hand, a two-year quest began.

While London slept, we climbed over palisade fencing and barbed wire onto gleaming tracks. We sprinted through stations, substations, vent shafts, layups and yards past seas of CCTV cameras, into empty tunnels after service. We dodged workers and other curious nocturnals eager to skirmish over control of subversive turf. We huffed asbestos-lined brake dust littered through the tunnels, knocking out station after station, addicted to the warmth and rolling rumble and thick black air and the thrill of stealing sneaky shots of secret spaces.

Inside Mark Lane, the station walls were plastered with withering posters from the past. We hid behind pillars as trains sped through, surging beams that illuminated soot-covered steel plates like something out of *Blade Runner*, an amalgamation of forgotten urban archaeology and mechanised transport technology. The adrenaline rush was, however, only part of the allure; tantalising glimpses of forgotten material heritage were available not just to see but to smell, taste and feel – the real treasure. Inside Down Street station, original tiling in pedestrian subways and wooden handrails in the stairwells were covered in decades of grunge. Around us, creamy, dust-covered walls were lit by eternally searing fluorescent lights. Rummaging further, we found Churchill's forgotten war rooms and relished the underappreciated history. The musty smell of damp cave mixed with tube dust, the unmistakable odour of discovery, also suffused Aldwych, where we could nap in an awkwardly perched 1972 Northern Line train carriage.

The deeper we went into the system, the greater the risk we took of not being able to escape if caught, by trains or workers. Framing, 'correct' exposure and tripod deployment become less of a priority. Conceding egos bled through each photo as the limits of what we thought was possible were stretched beyond comprehension.

Myths, a vital component of London's underground history, are rife in the tube, where multiple, often parallel, histories of place are constructed through experience, memory, forgetting and political agendas. It became clear that the places we had been excluded from could be easily erased from public history without much ado. Our photos, then, were documenting what may never be seen otherwise, slices of time and place, archives of experience entangled with impossibly interesting material histories. Soon the ghost stations didn't matter any more; the goals were subsumed by the process.

Running from an encircling force of British Transport Police officers in the system on Christmas Day 2012, we snapped a few shaky handheld photos before heading to the nearest portal out of the tube system onto an eerily quiet street, where we escaped down a dark alley. We returned a few days later and found the fire escape door still open. It's all part of the recipe for transport infiltration – a bit of skill, a bit of luck and a lot of persistence. Willingness and desire to tackle the tube is what came to define us as explorers. We didn't always succeed, but when we did, we changed the rules of the game.

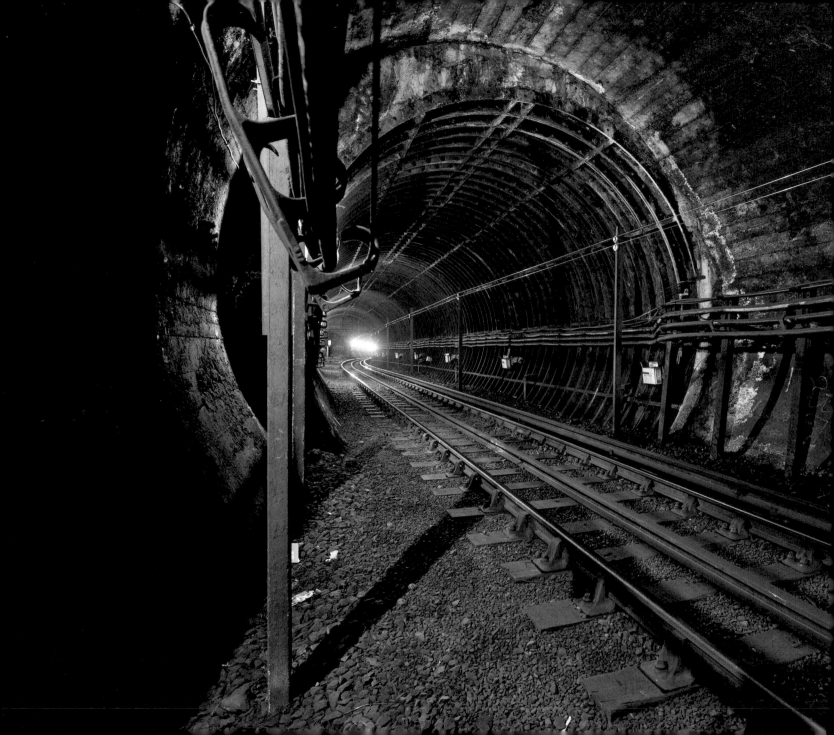

THE SPRAWLING RADIAL THAT KEEPS BODIES MOBILE, THE FIRST IN THE WORLD, CONTAINS 120 MILES OF UNDERGROUND TRACK. THE SYSTEM IS RIVEN WITH FAILURES, OMISSIONS, ERRORS AND REWORKINGS.

◄ Built by the Great Northern & City Railway in 1904, the Northern City Line (NCL) ran from Moorgate to Finsbury Park, with tunnels spanning the widths of mainline trains.

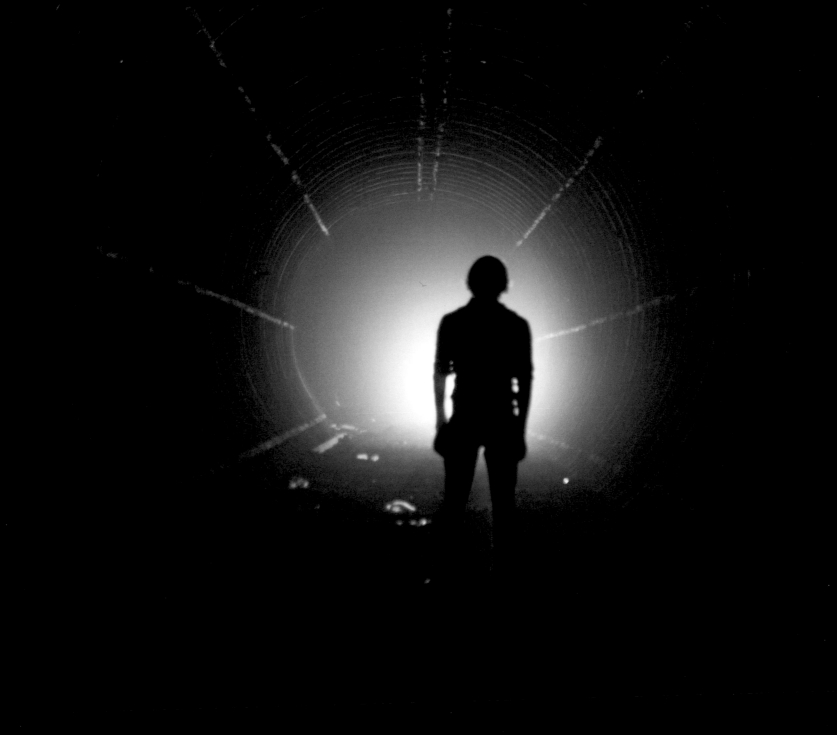

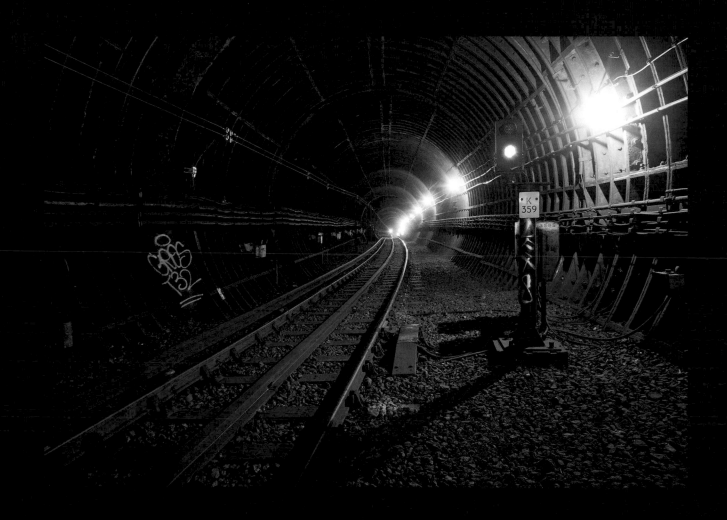

◀ In 1964, as a result of the extension of the Victoria Line, the NCL service was cut at Drayton Park, sections of the tunnels lying dormant between active tunnels.

▲ A red light would hold a train in the NCL, giving us time to run the tracks.

► Thirty-year-old straw stalactites fringing the metal rings of the NCL.

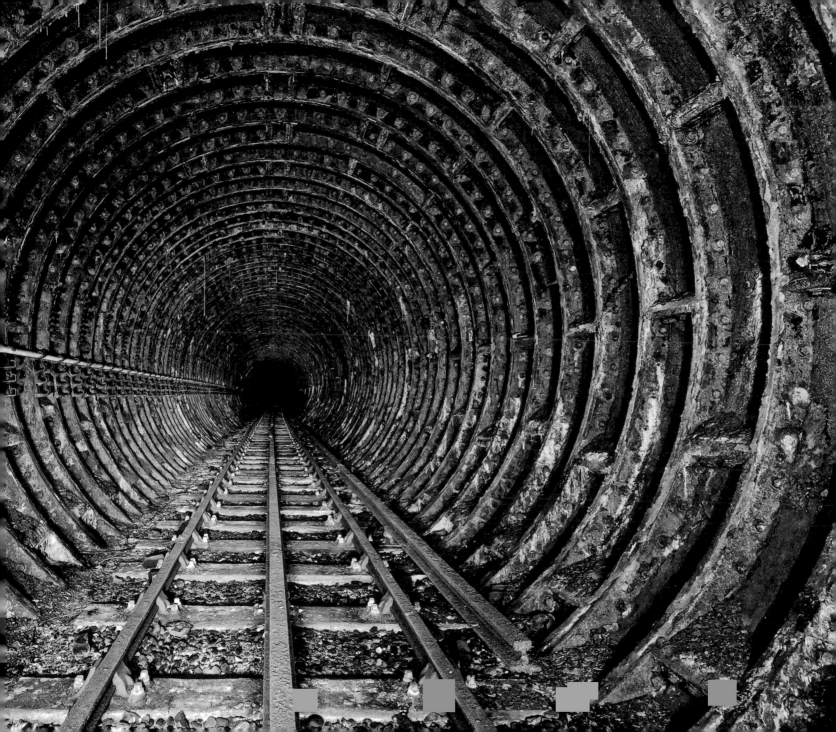

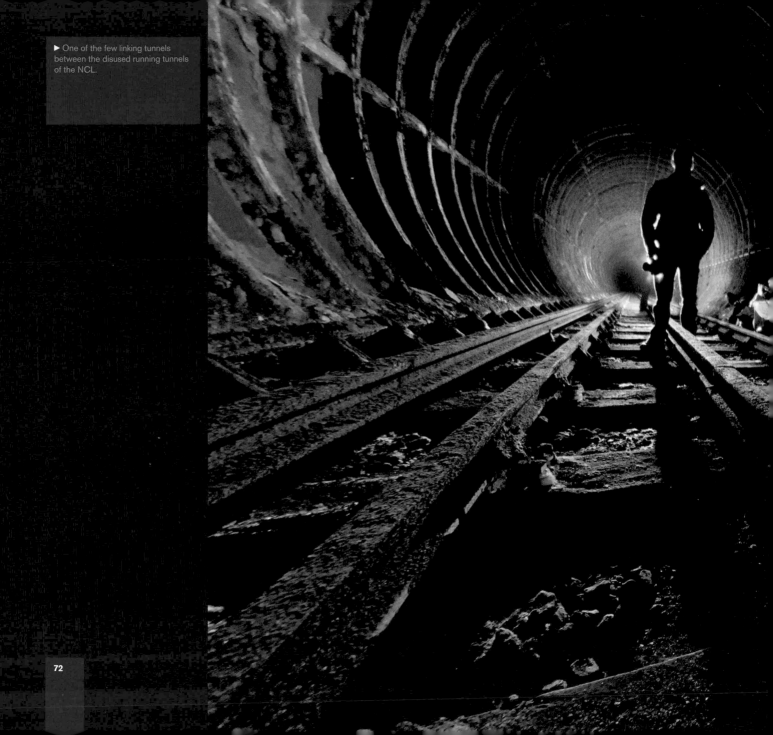

▶ One of the few linking tunnels between the disused running tunnels of the NCL.

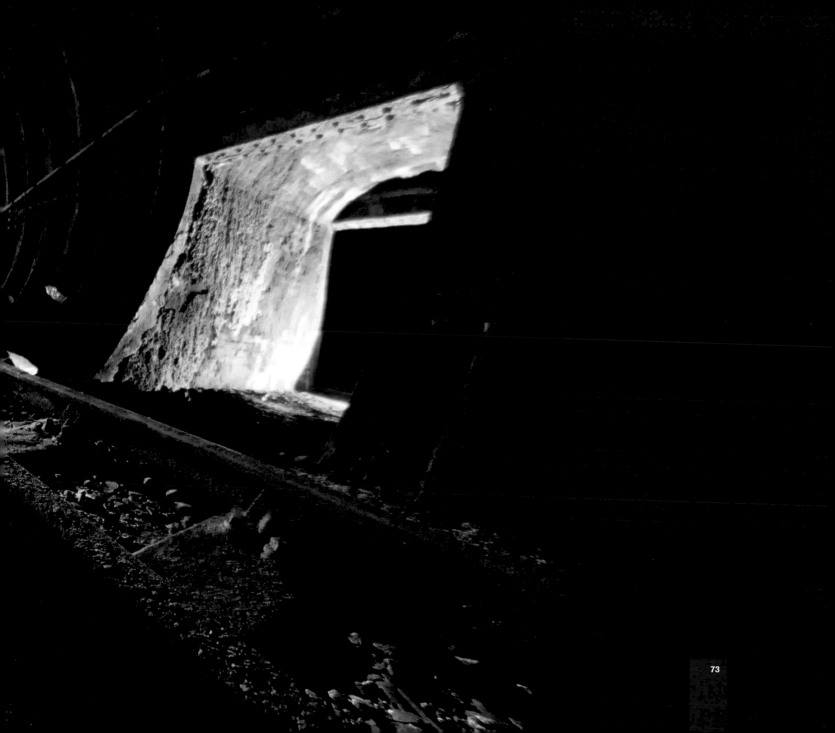

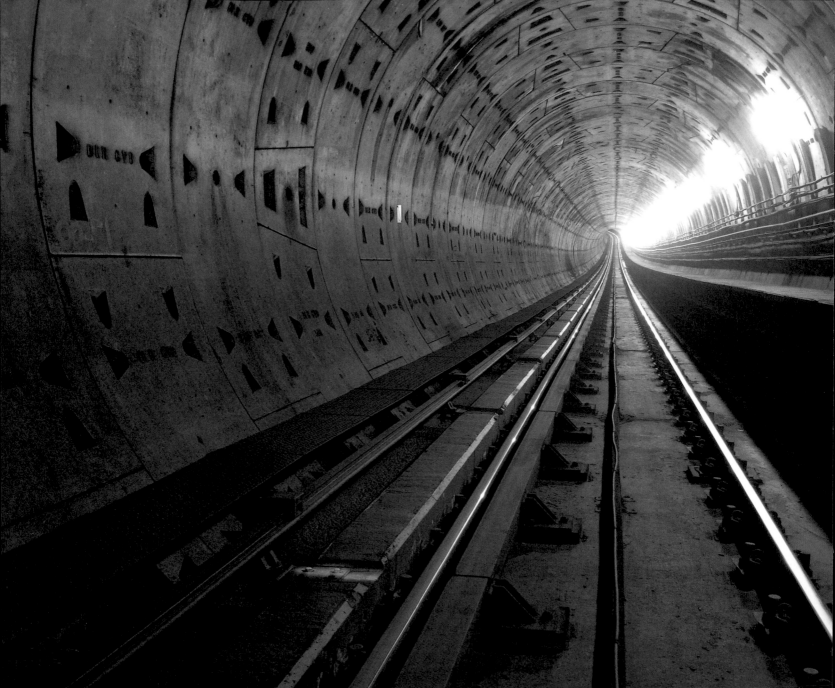

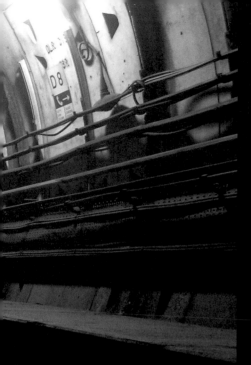

◄ Docklands Light Railway tunnel running under the Thames: dug out by a 540-tonne tunnel-boring machine.

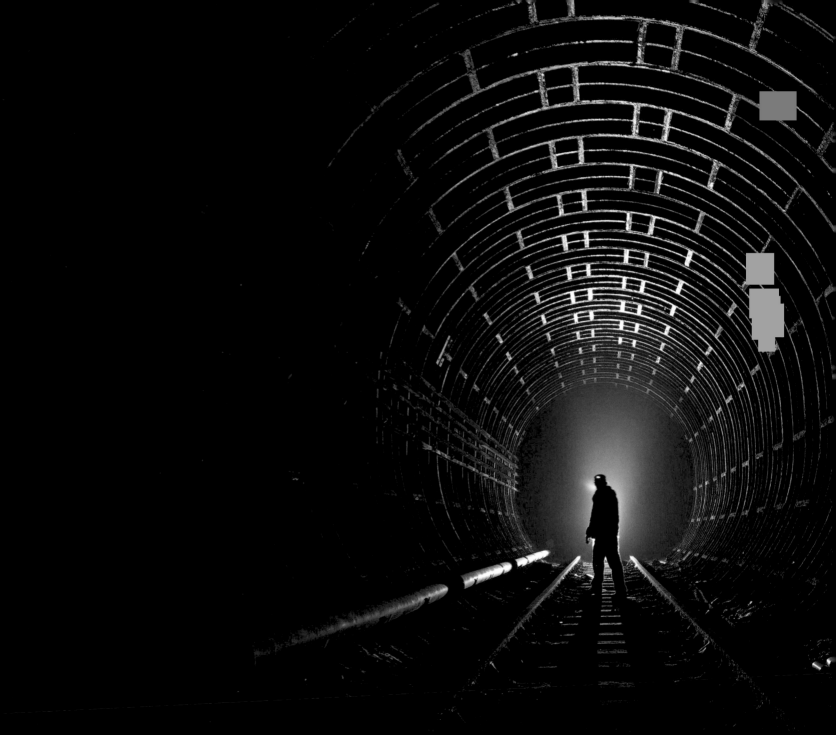

◄ A relic from the age of steam locomotion, the tunnels here were built with enough clearance to accommodate steam carriages, much larger than modern tube trains.

▲ Although not technically underground, this inaccessible disused station building near Shoreditch houses some fascinating machinery from the time it was in use.

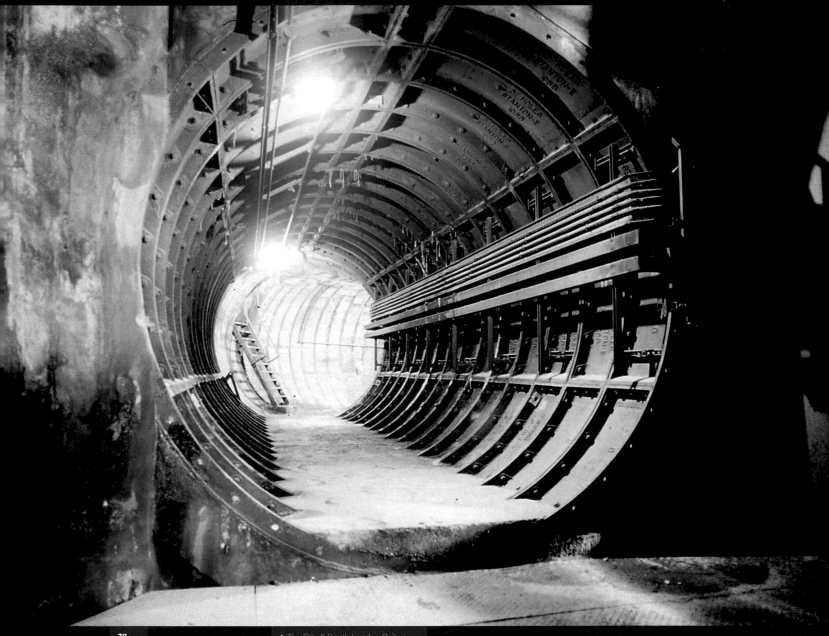

▲ The City & South London Railway tunnels, London Bridge, near the disused station King William Street form part of the world's first deep-level underground railway.

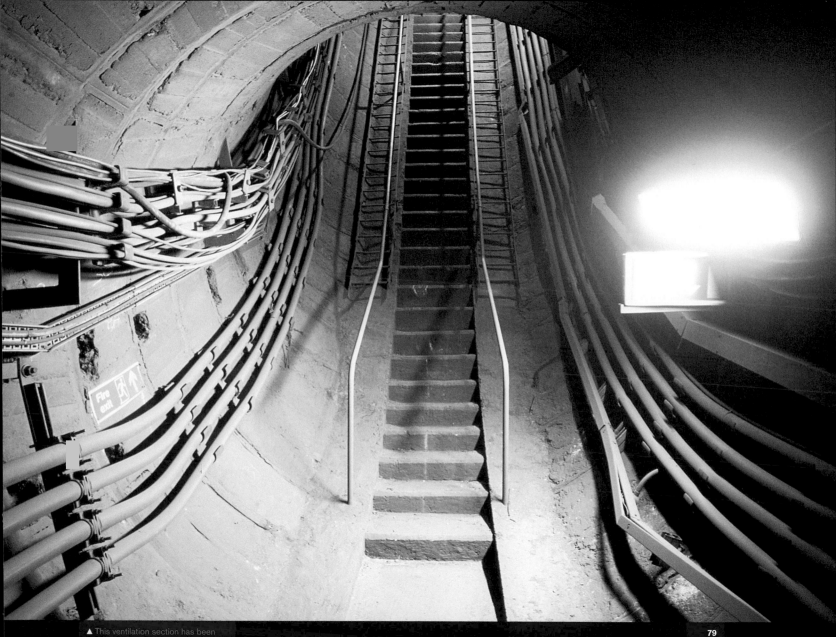

MYTHS, A VITAL COMPONENT
OF LONDON'S UNDERGROUND HISTORY,
ARE RIFE IN THE TUBE, WHERE MULTIPLE,
OFTEN PARALLEL, HISTORIES OF
PLACE ARE CONSTRUCTED
THROUGH EXPERIENCE, MEMORY,
FORGETTING AND POLITICAL AGENDAS.

◀ It is an uncanny feeling seeing the faces of passing passengers as you stand in the shadows just a few feet away from them.

▲ At the Magic Door, a security hole into the deep-level system, risks are confronted to get a glimpse of trains flying by at high speed, inches from our faces.

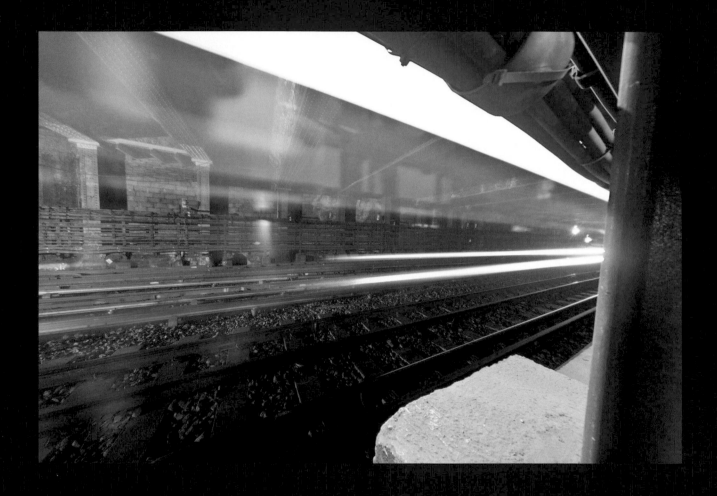

▲ The disused station Mark Lane, up close and personal.

▶ Lords station, one of three abandoned stations between Baker Street and Finchley Road that were superseded by stations on the Jubilee Line running alongside.

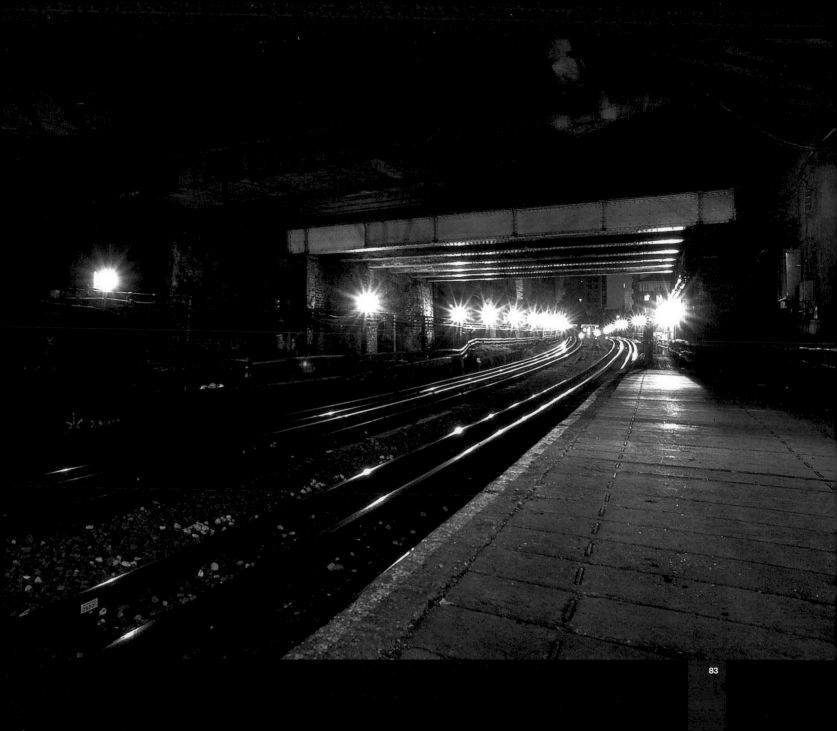

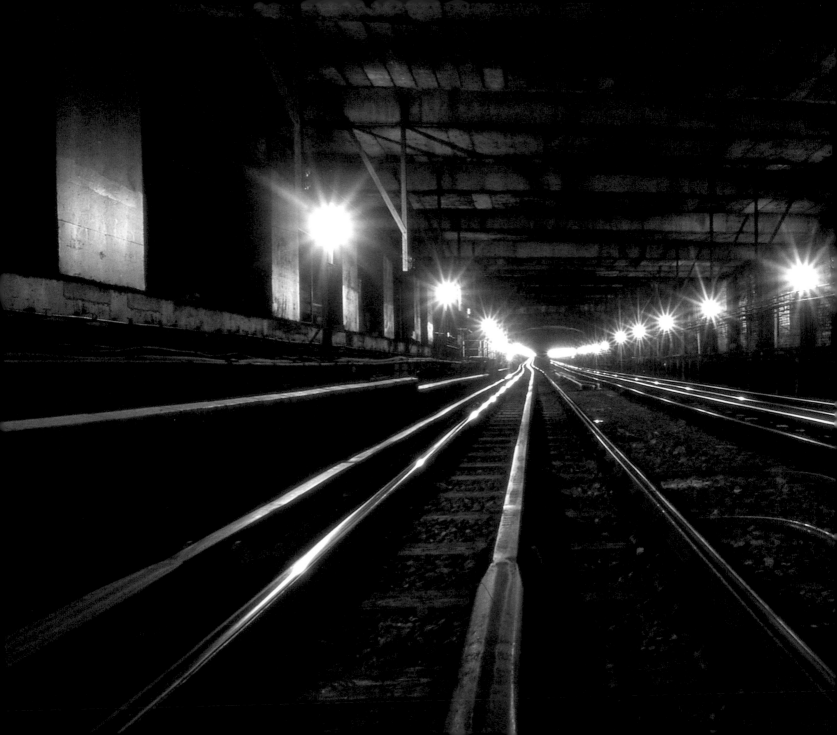

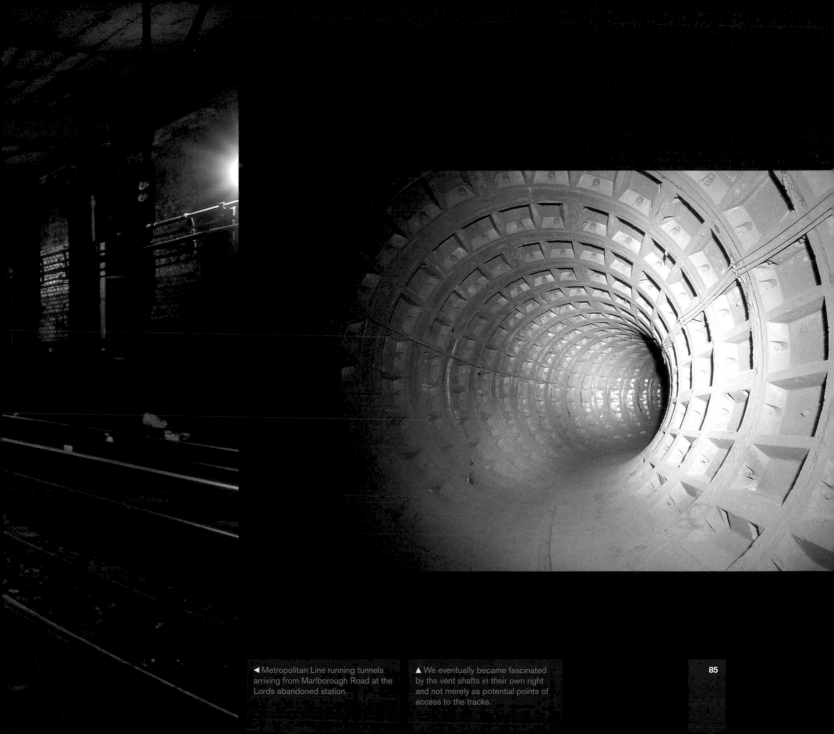

◄ Metropolitan Line running tunnels arriving from Marlborough Road at the Lords abandoned station.

▲ We eventually became fascinated by the vent shafts in their own right and not merely as potential points of access to the tracks.

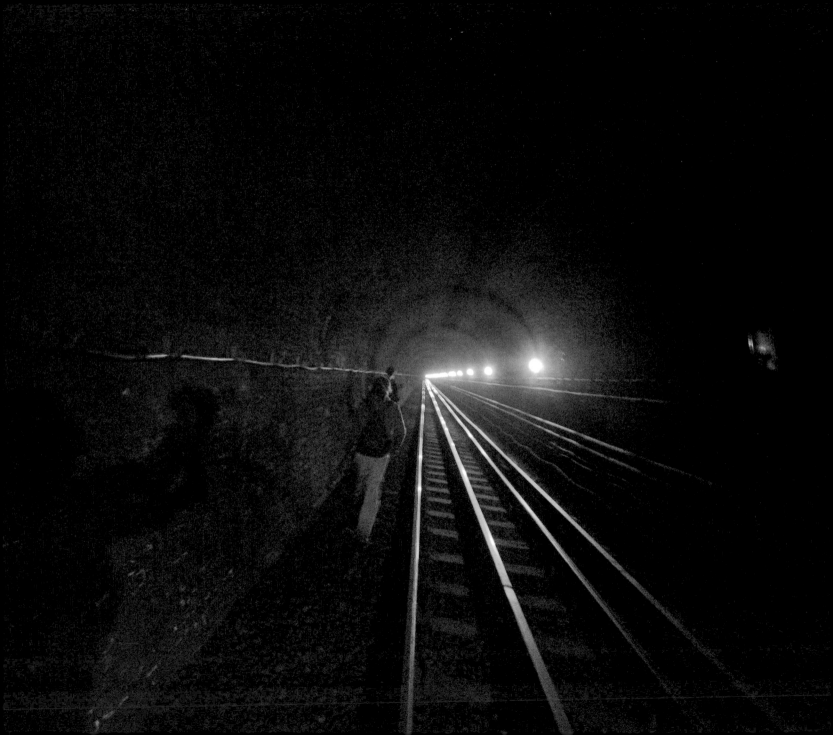

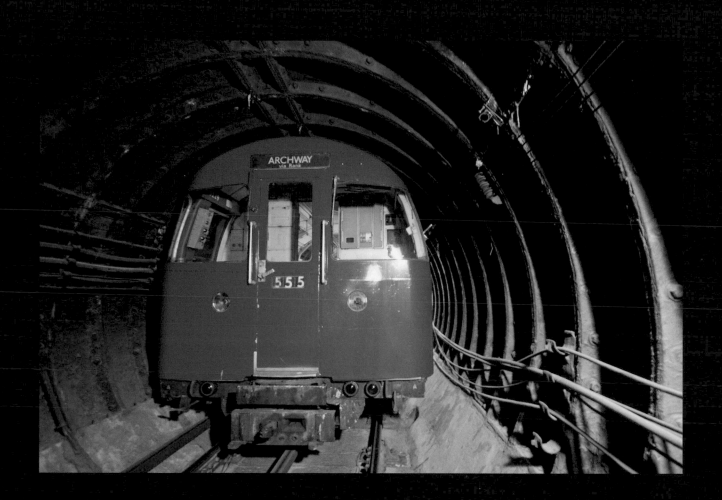

◀ Even with the (scant) clearance the mainline gauge of the NCL offers, track-walking is fraught with anxiety.

▲ The crown jewel of the system is Aldwych, which used to be known in the early 1900s as Strand station.

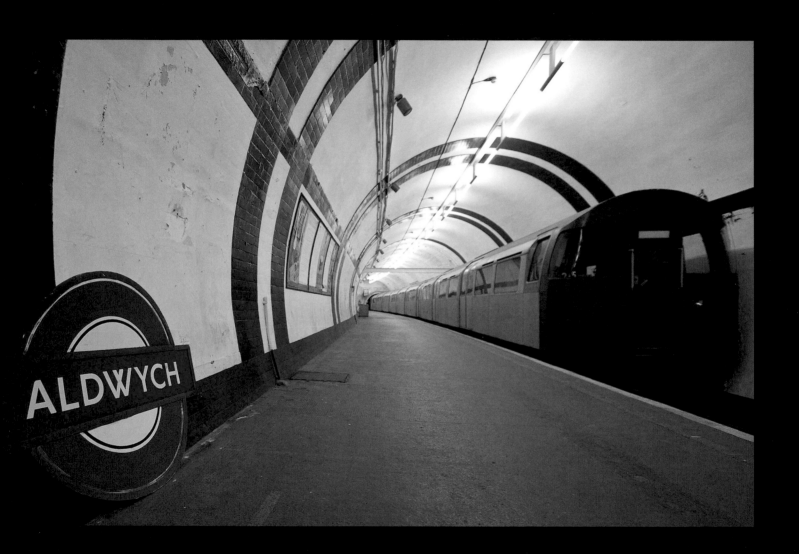

ALDWYCH

▲ The station closed in 1994 but had been used, like many stations, as an air raid shelter during World War II.

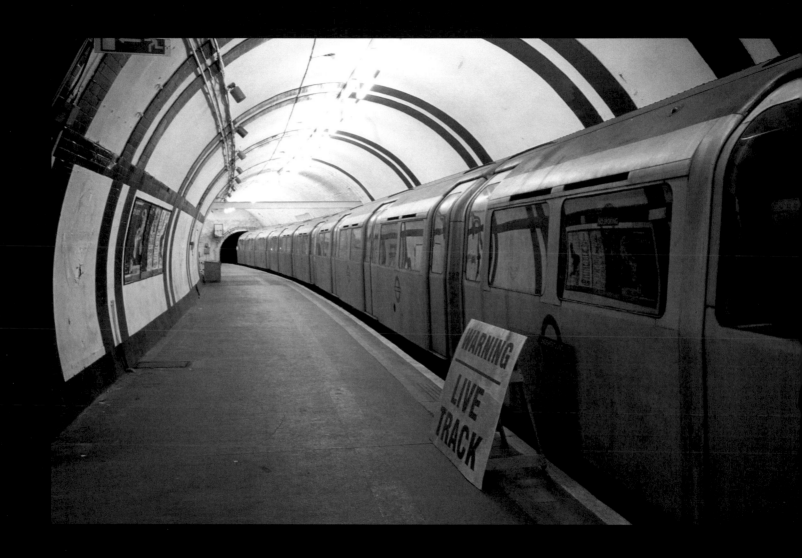

▲ The most interesting thing about
the station was that there was a 1972
Northern Line train, awkwardly on the
Piccadilly Line, permanently stabled
there for filming purposes.

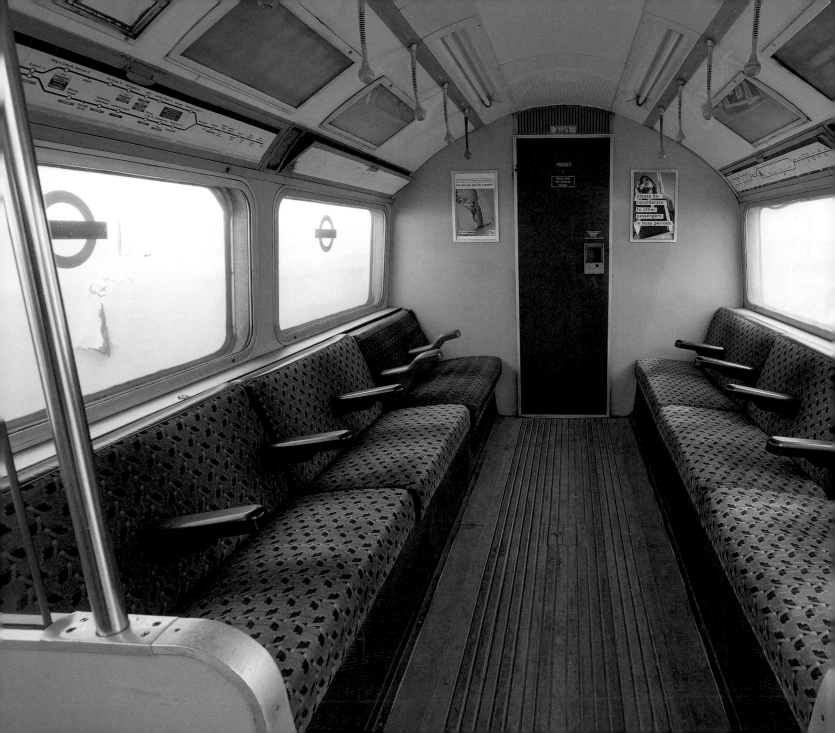

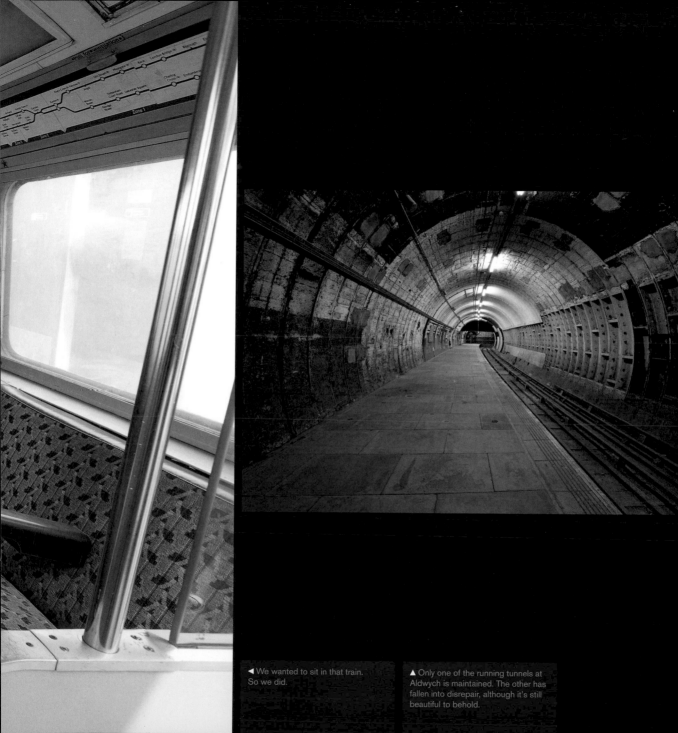

◀ We wanted to sit in that train. So we did.

▲ Only one of the running tunnels at Aldwych is maintained. The other has fallen into disrepair, although it's still beautiful to behold.

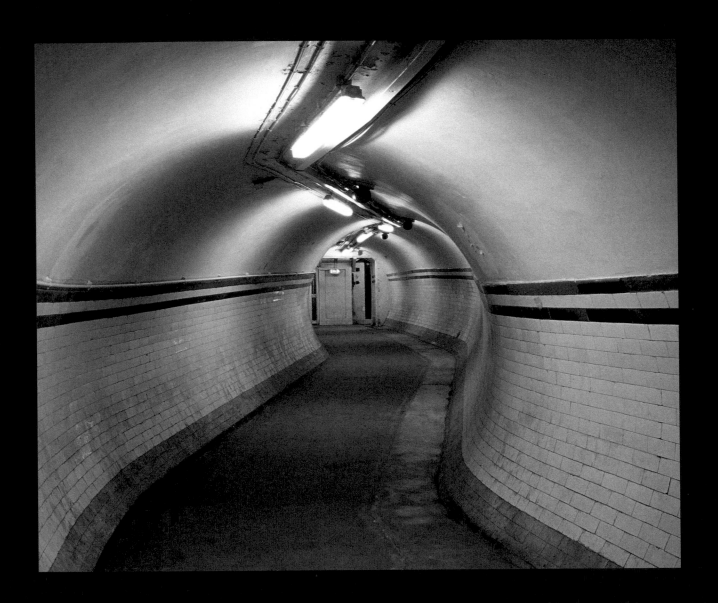

▲ The famous S-curve passenger
linking tunnel at the Aldwych
abandoned station.

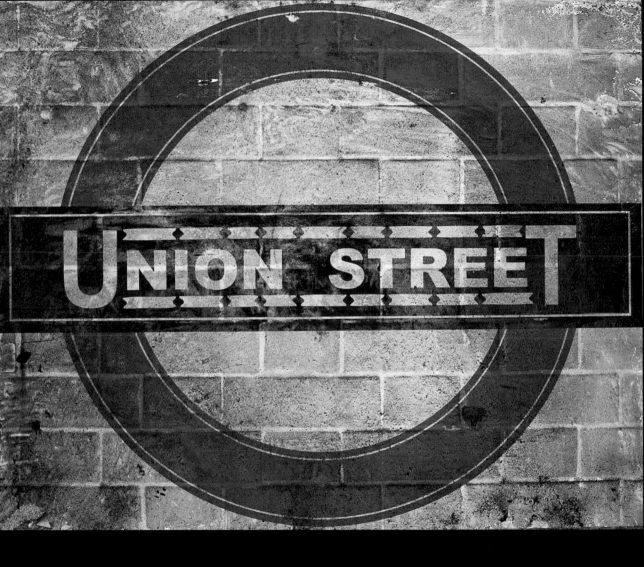

▲ Union Street station does not exist. This is actually the Holborn Tramway station. The sign here is from the film *The Escapist* (2008), part of which was shot in the station.

▶ Frozen in time, the Holborn disused
sections are now used only by staff
and for maintenance access and
storage of materials.

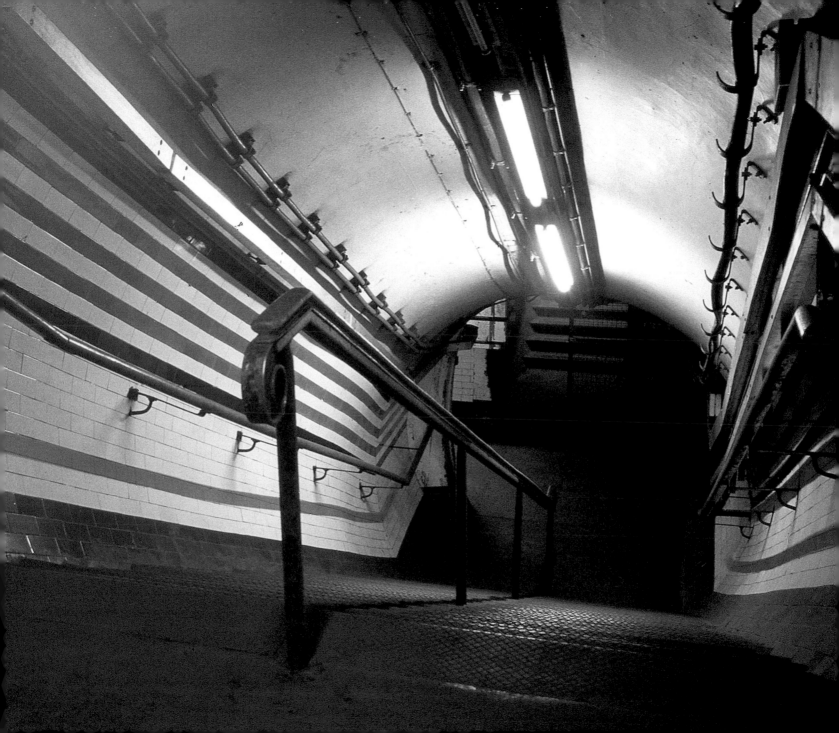

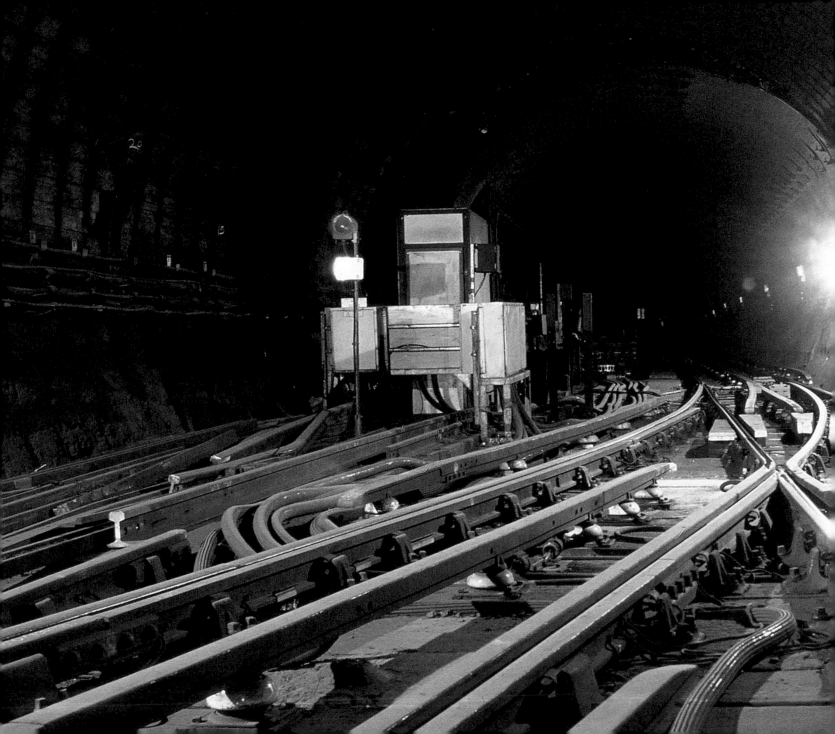

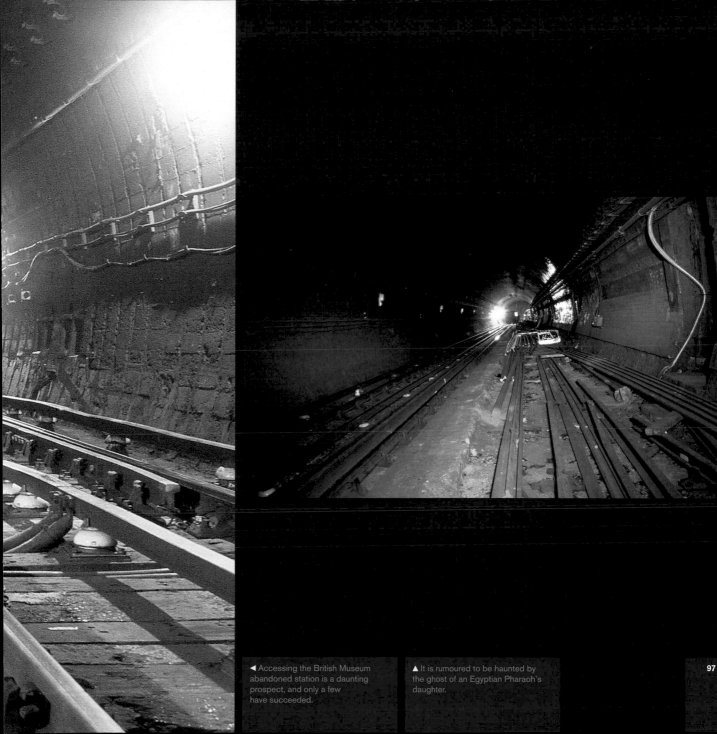

◀ Accessing the British Museum abandoned station is a daunting prospect, and only a few have succeeded.

▲ It is rumoured to be haunted by the ghost of an Egyptian Pharaoh's daughter.

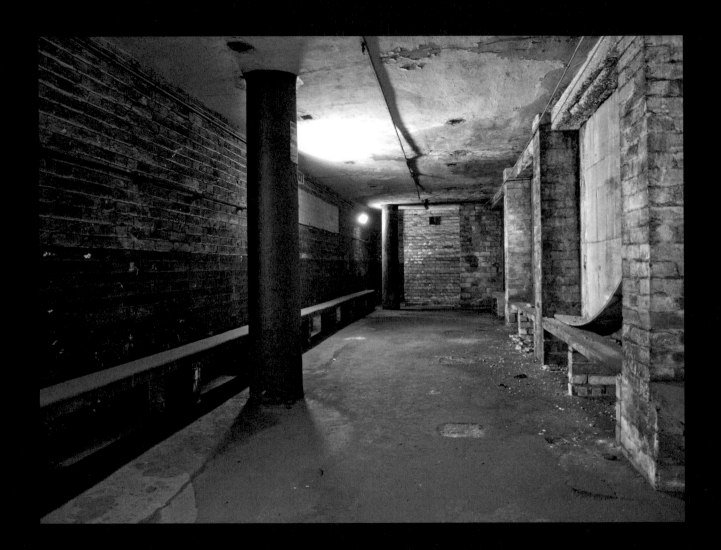

▲ St Mary's station building was destroyed by a World War II bomb in 1940, leaving only subsurface remains.

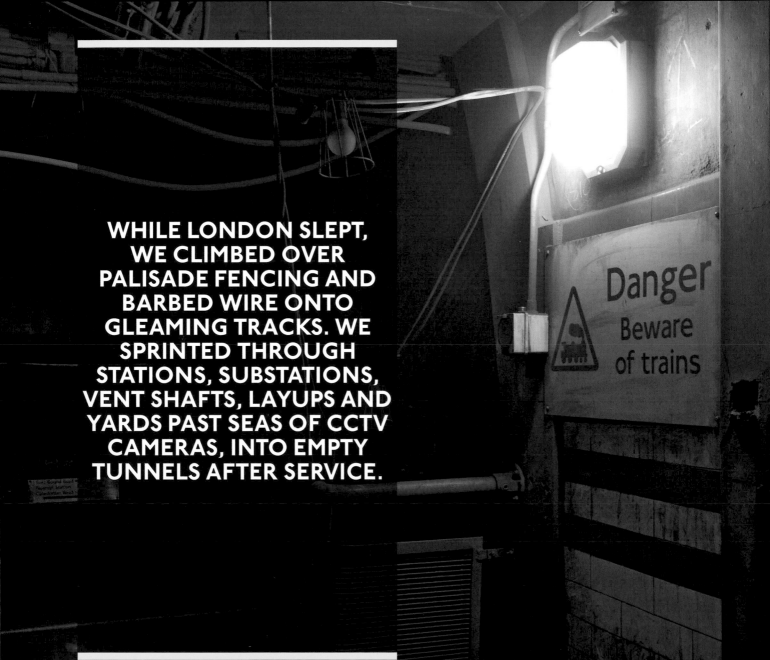

WHILE LONDON SLEPT, WE CLIMBED OVER PALISADE FENCING AND BARBED WIRE ONTO GLEAMING TRACKS. WE SPRINTED THROUGH STATIONS, SUBSTATIONS, VENT SHAFTS, LAYUPS AND YARDS PAST SEAS OF CCTV CAMERAS, INTO EMPTY TUNNELS AFTER SERVICE.

Danger
Beware
of trains

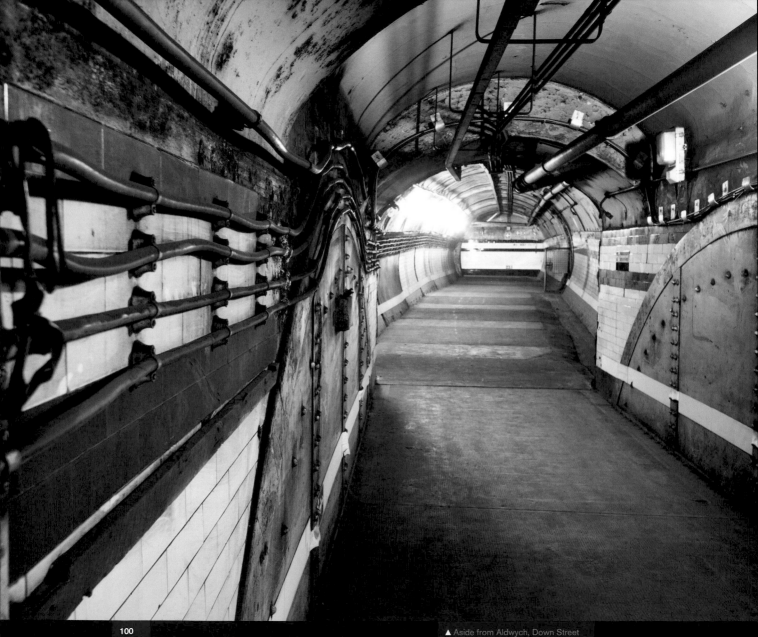

▲ Aside from Aldwych, Down Street

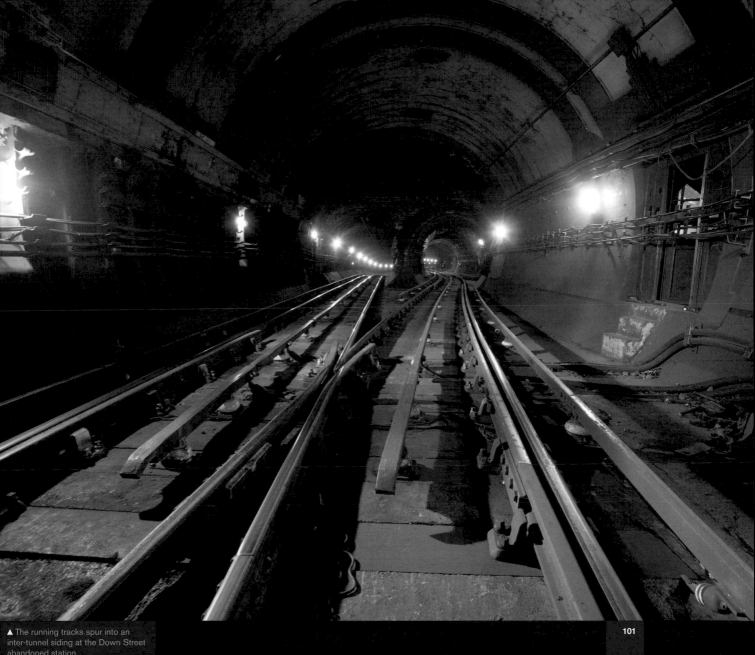

▲ The running tracks spur into an
inter-tunnel siding at the Down Street
abandoned station.

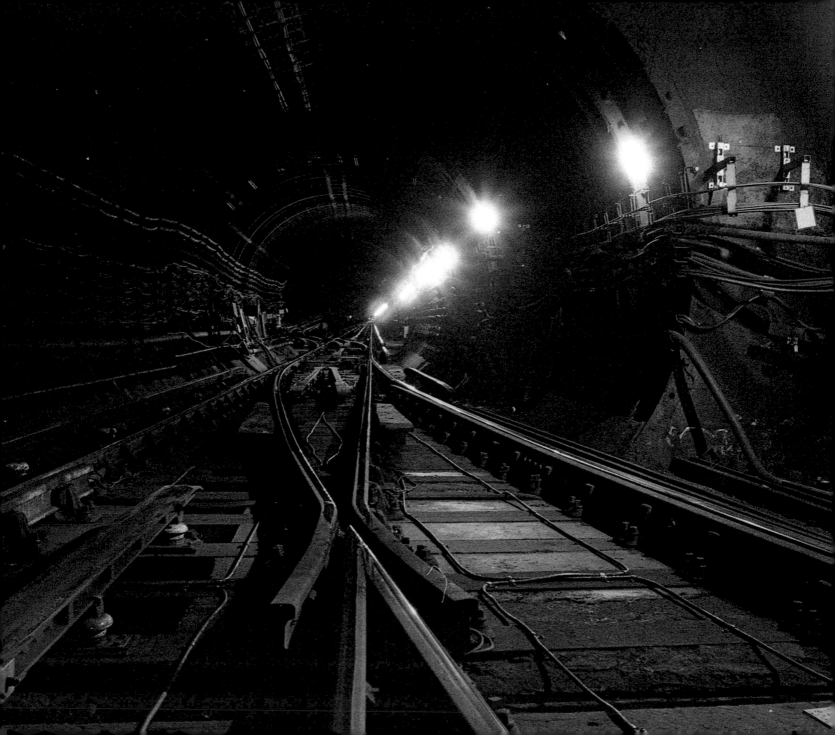

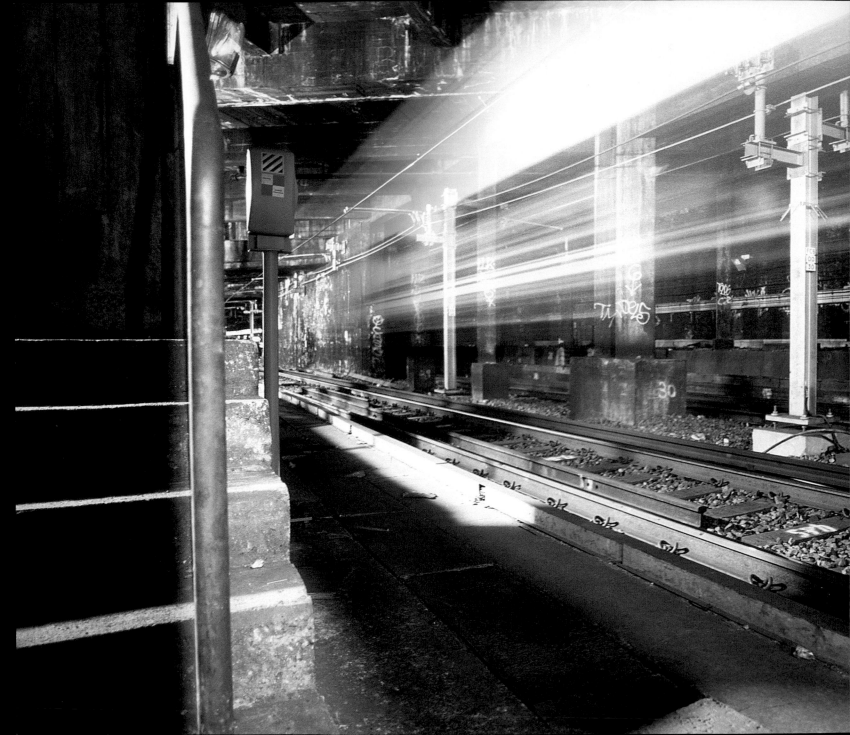

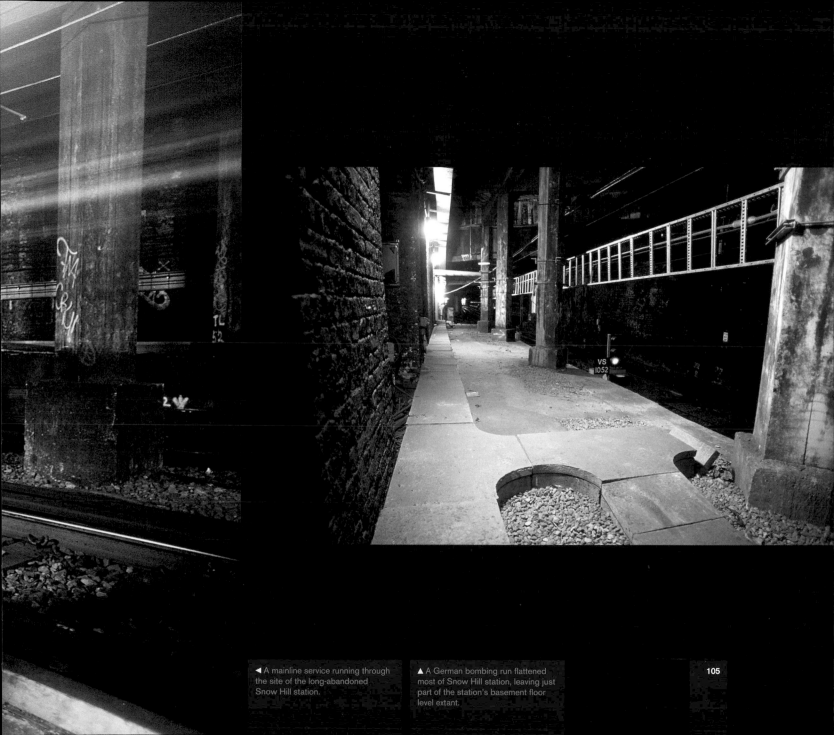

◀ A mainline service running through the site of the long-abandoned Snow Hill station.

▲ A German bombing run flattened most of Snow Hill station, leaving just part of the station's basement floor level extant.

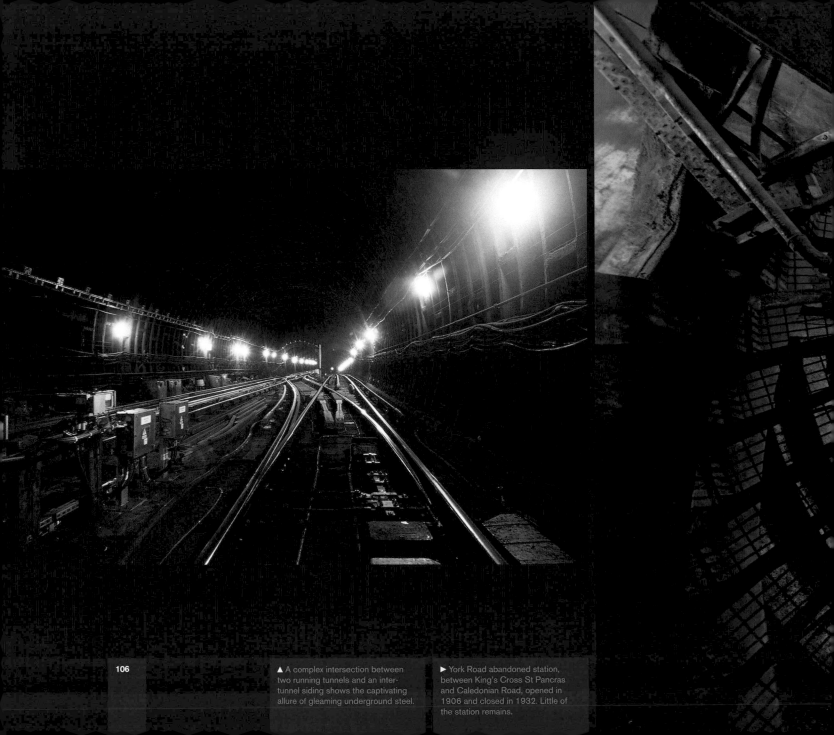

▲ A complex intersection between two running tunnels and an inter-tunnel siding shows the captivating allure of gleaming underground steel.

▶ York Road abandoned station, between King's Cross St Pancras and Caledonian Road, opened in 1906 and closed in 1932. Little of the station remains.

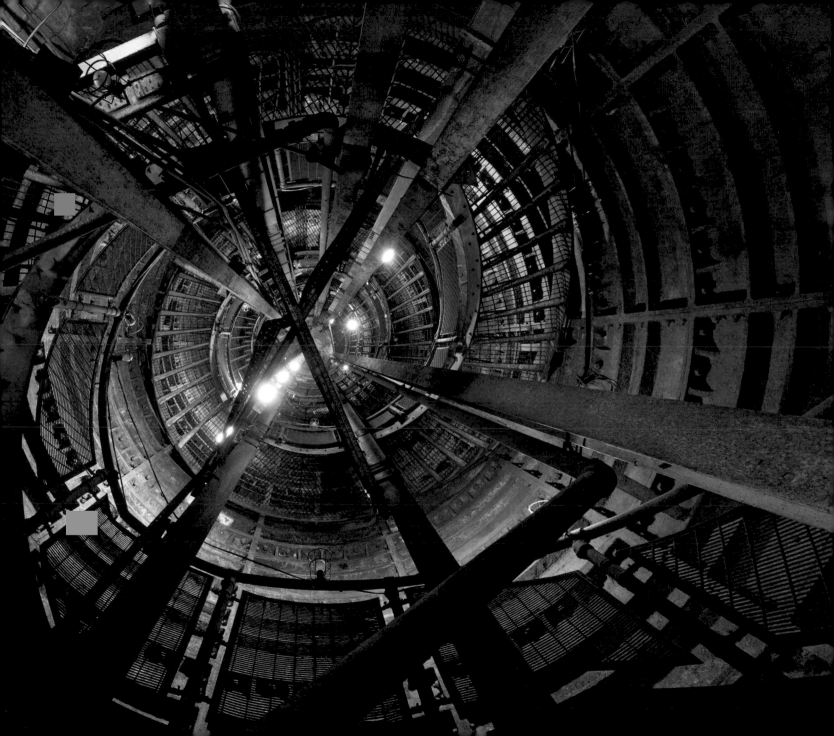

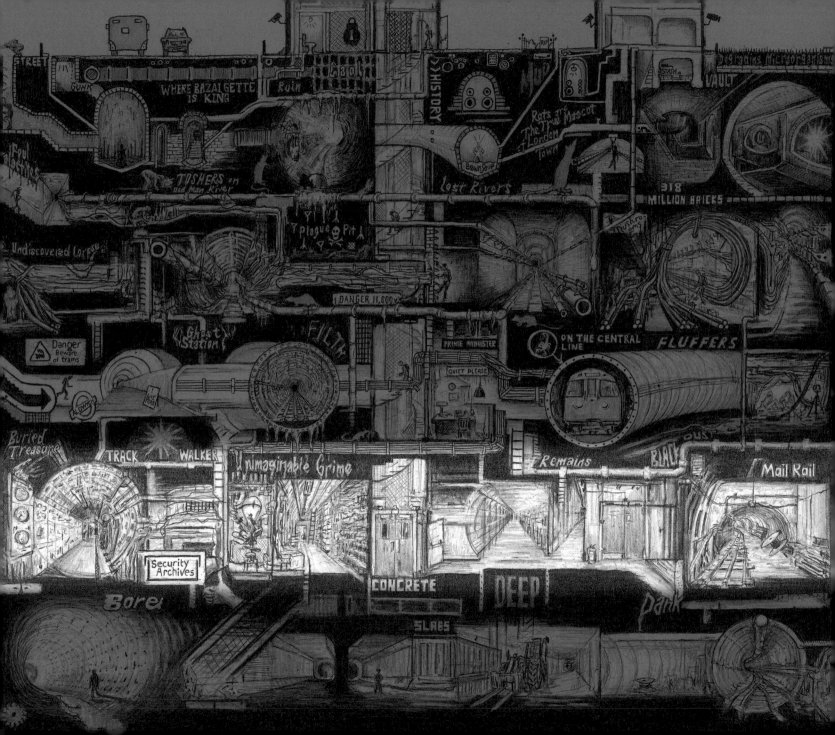

SHELTER

London is a city of conflict. From international wars to everyday battles for space on the streets, each solar cycle brings renewed conflict, which is, like most things, reflected in the subterranean infrastructure of the city. Entering the tube, as it turned out, only opened deeper doors.

As the capital of the Sceptred Isle, London has a proud military history in which underground tunnels played an increasingly prominent role through time. Mounting use of aerial bombardment during World War II encouraged the re-implementation of Brunel's tunnelling shield, harnessed anew to create a system of deep-level shelters. The project, originally intended for the exclusive housing of fundamental government intelligence and tactical operations, diversified into a system of eight public shelters stretching from Belsize Park to Clapham: sub-urban citadels harbouring Londoners while their homes and businesses were being reduced to rubble by unforgiving Luftwaffe blitzes. Our imaginations were piqued by the possibility of successfully accessing covert subterranean spaces steeped in military history – however, at 40 metres underground, surrounded by a haze of mythology, misinformation and mystery, the odds were stacked against us.

One winter night, we lowered ourselves on ropes through a ventilation shaft into the Clapham North bunker and ventured over the threshold of a new frontier. The tunnels of the deep level were unlike anything we'd experienced before. The mouldy dry air and heat drifted in waves through complete darkness. Reverberations of nearby Northern Line trains teased behind bricked-up breezeblock walls. A flick of a light switch ignited a slow-burning hum, gradually building into a shrieking electric buzz, as, one by one, strip lights tinkled into life, sequenced down the tunnel arches, bathing vast wings with a familiar cinematic fluorescent glow. Walking miles of empty tunnels, we found it difficult to comprehend the rent per square foot we paid for our flats.

Weeks later, in Clapham South, we located a coveted mercury arc rectifier tucked into a tiny control room, an alien piece of machinery once used to convert alternating current to direct current. The Clapham Common shelter was the final bunker to be infiltrated to complete the triptych. Based on our experiences in the others, we expected to encounter a similarly stripped-out concrete husk. However, after abseiling down an airshaft and squeezing through a ventilation system, we emerged into what appeared to be a 'secure' document storage. Exit via the rope we slid down not being an option, we spent the evening rummaging through bank documents, scuttled plans from engineering companies and BBC cartoons stored on obsolete tape systems.

The shelter at Chancery Lane held unique value. In 1949, it was sold to the GPO, at which point it became the termination for the first submarine transatlantic phone cable. The tunnels had at one point contained a bar within them for off-the-clock workers, rumoured to be the deepest in the UK at 60 metres. The system was a strict spatial secret of state, revealed first in 1980 by journalist Duncan Campbell, who infiltrated the tunnels equipped with a bicycle and a camera. Campbell relayed access details for the infiltration via the *New Statesman*, which, 30 years later, got us in. Kingsway, and the connections it harboured to the BT Deep Level Exchange, the country's most tightly guarded infrastructural artery, brought us to the brink of triumphant mania; the shallow cable runs of our yesteryear seemed dim spectres in comparison, as we crept through the central trunk of British Telecommunications.

A final deep-level secret remained hunted for, however. From Paddington to Whitechapel, a 6.5 mile system deeper than the tube was also owned by the GPO. It was built in 1927 to take letters across the city in tiny trains called mini yorks but was mothballed in 2003. Few had seen it since, until one night when we gained access via a postal sorting office and the Mail Rail was given a new lease of life. The abandoned tunnels, after only a decade, were already calcifying, filling with stalactites and stalagmites. The imagination ran wild with dreams of the miniature Post Office Railway in 100 years morphing into a natural cave, with old burlap postal bags and tiny trains being sucked into the tunnel walls, frozen in skeletal horror. With the Mail Rail mapped, many considered London's spatial mysteries solved.

▶ These bombproof submarine doors were used to lock off certain sections of the Westminster Kingsway Telephone Exchange.

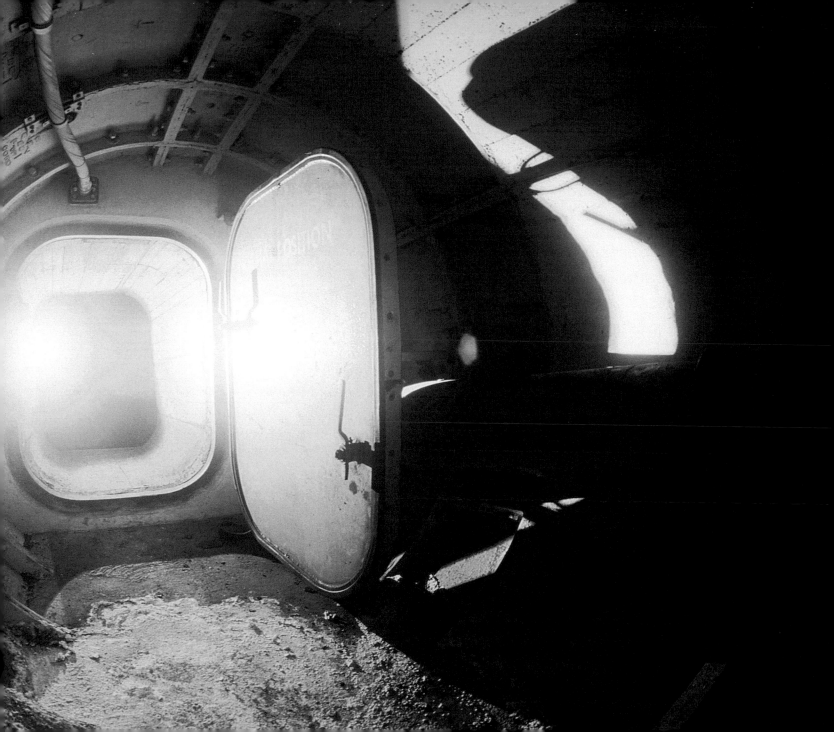

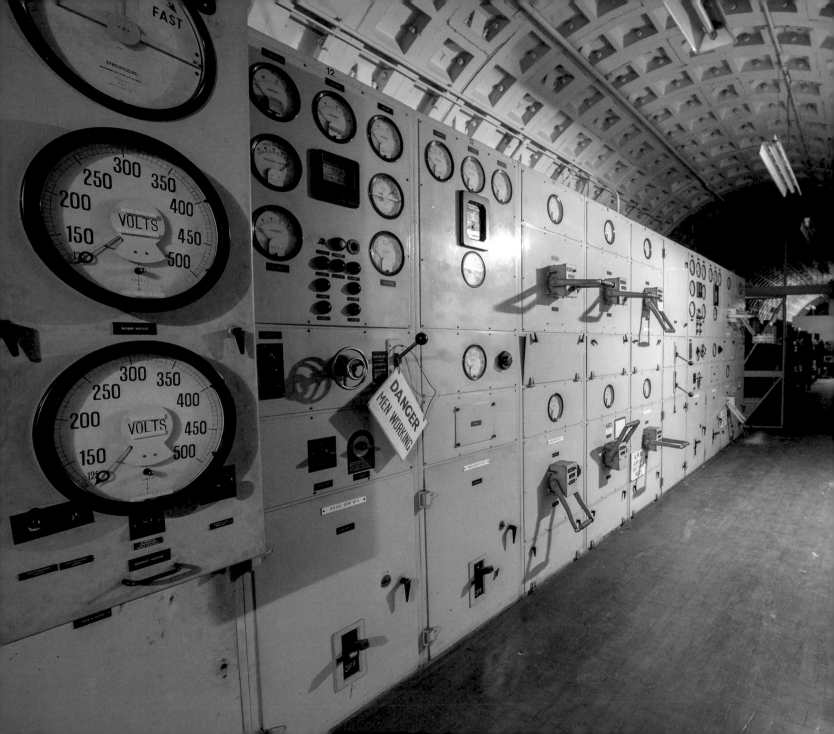

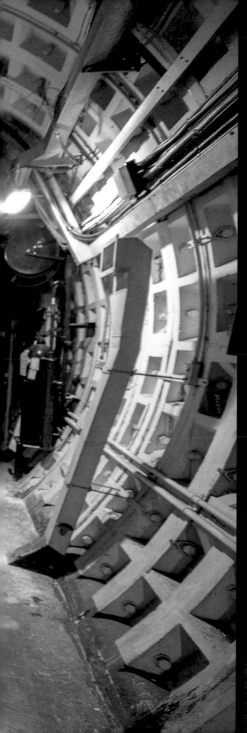

◄ The beautiful enamelled switchgear in the Kingsway Telephone Exchange.

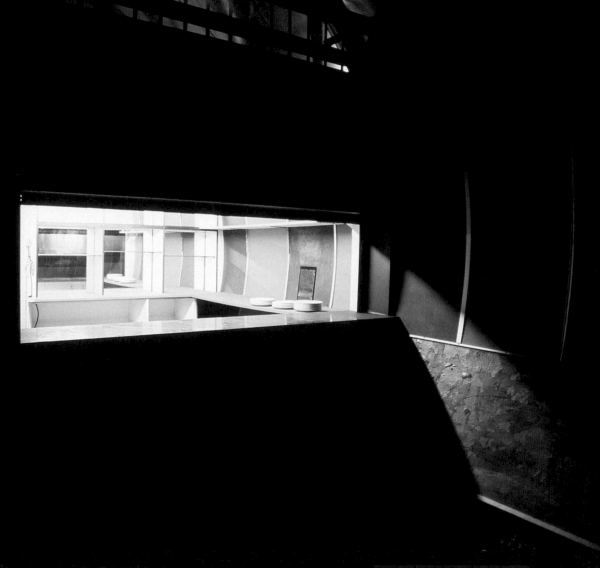

▲ Rumoured to be the deepest bar in the world, the Kingsway Exchange bar was on hand for telecoms workers to slake their thirst after a long shift underground.

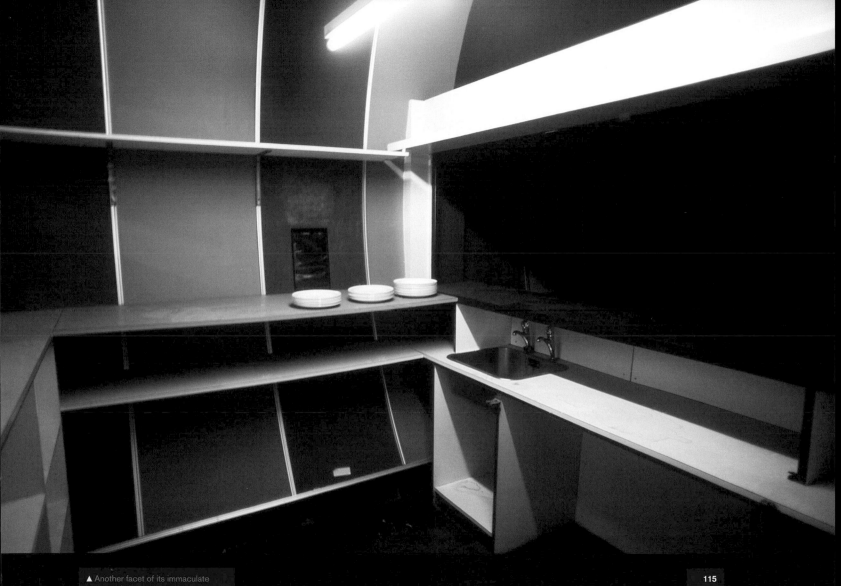

▲ Another facet of its immaculate preservation: the décor had remained unchanged for over 30 years, since it was last in use.

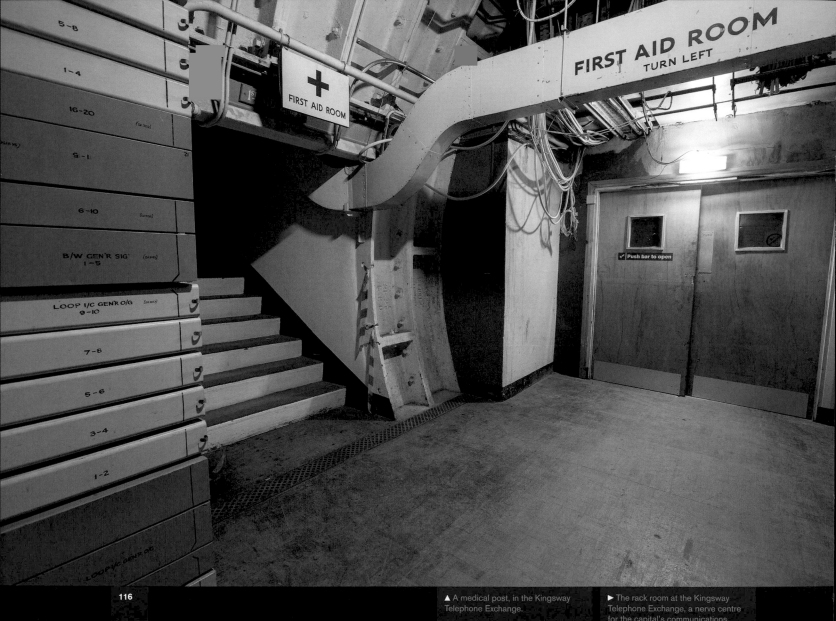

FIRST AID ROOM

✚
FIRST AID ROOM

FIRST AID ROOM
TURN LEFT

✓ Push bar to open

5-8

1-4

16-20

9-1

6-10

B/W GEN'R SIG
1-5

LOOP I/C GEN'R O/G
9-10

7-8

5-6

3-4

1-2

▲ A medical post, in the Kingsway
Telephone Exchange.

▶ The rack room at the Kingsway
Telephone Exchange, a nerve centre
for the capital's communications,

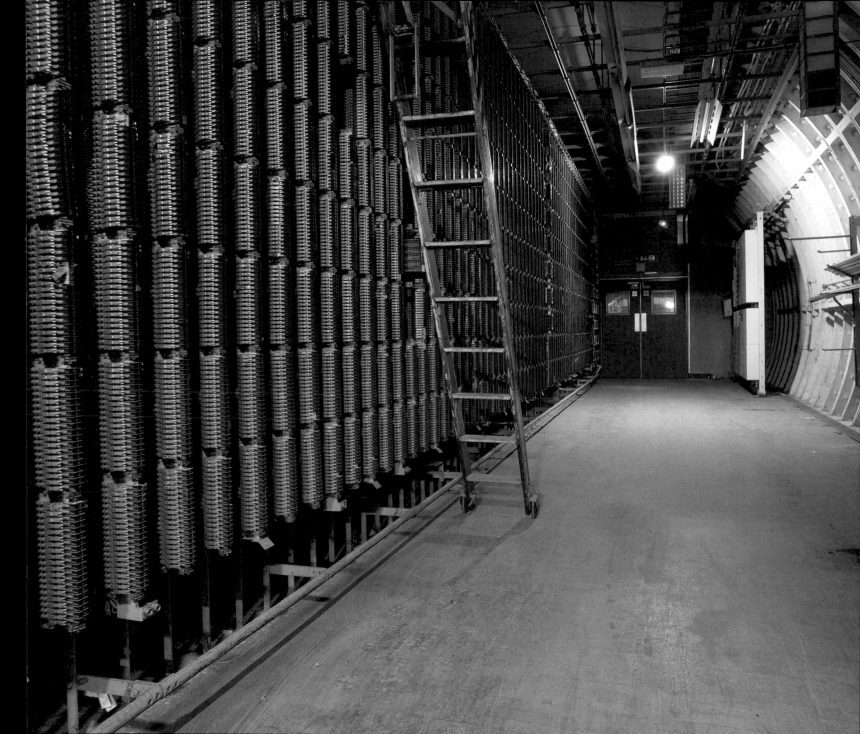

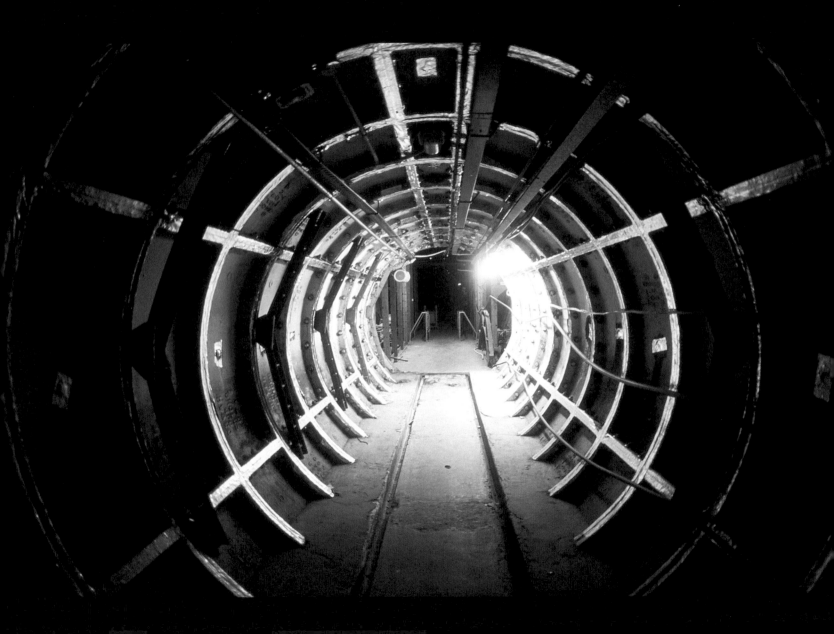

▲ The portal between the Kingsway Telephone Exchange and the deep-level BT cable tunnels.

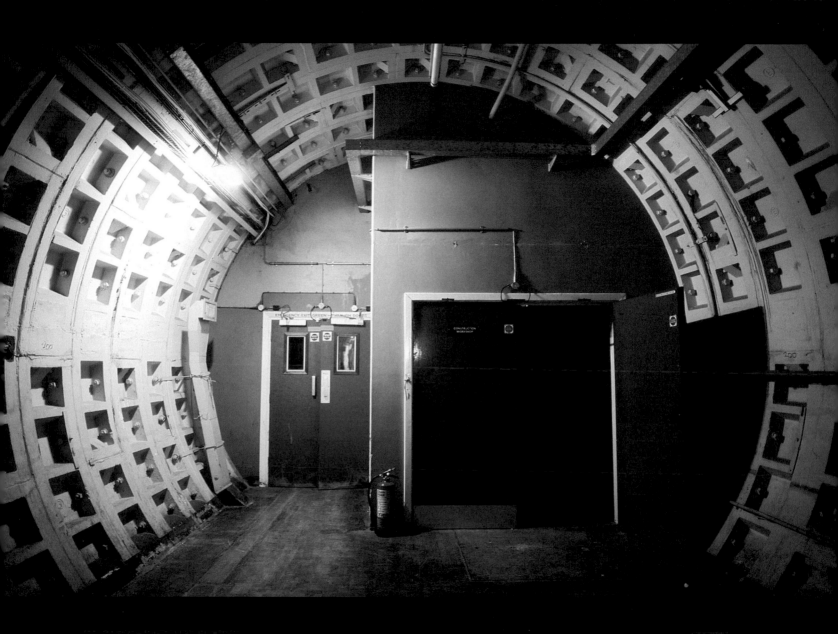

▲ The bold 1950s colour schemes of
the Kingsway Telephone Exchange.

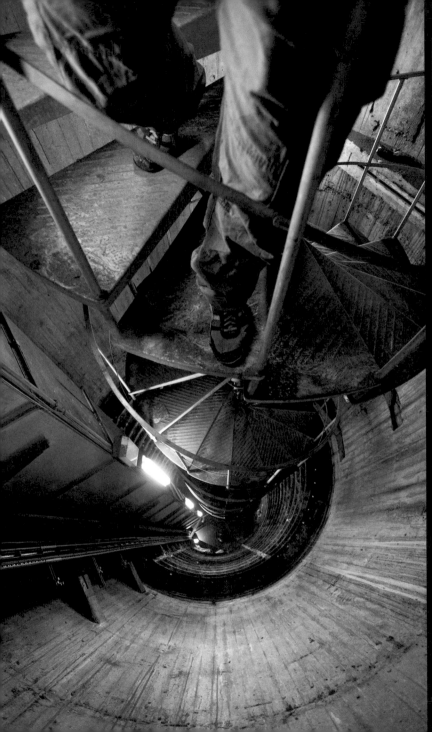

◄ Entry to deep-level systems often requires rope techniques. Every once in a while, however, one lucks out and finds stairs.

► A curved linking tunnel connecting several otherwise discrete sections of the Kingsway Telephone Exchange.

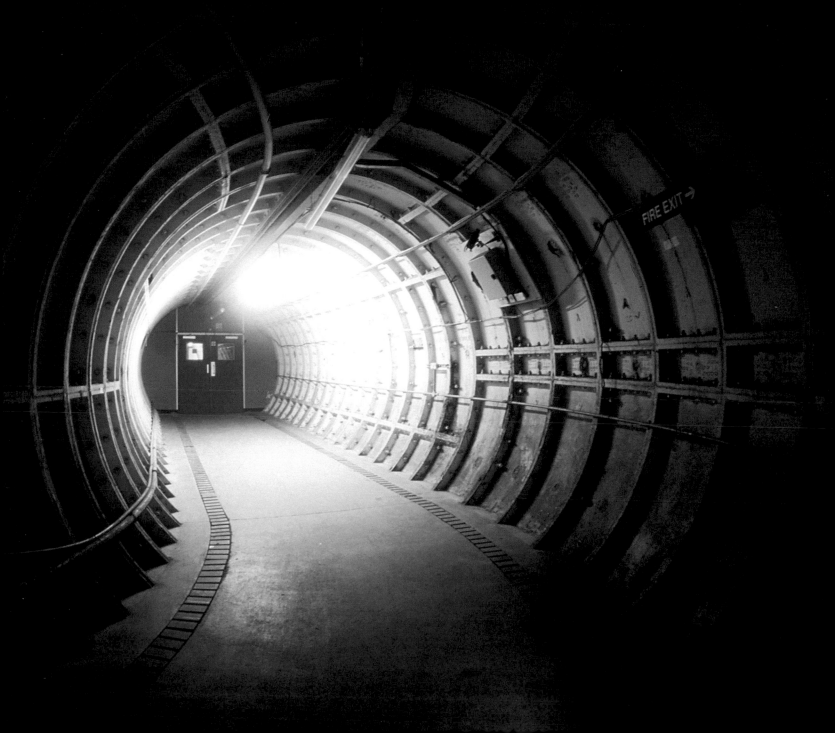

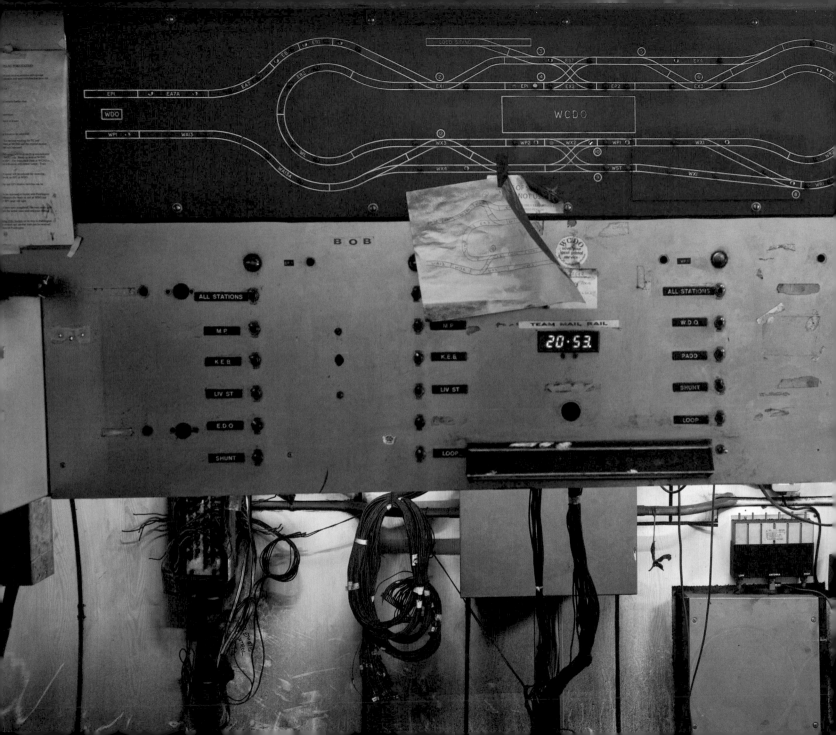

◄ A schematic of the loops and
sidings at the Mount Pleasant Mail
Rail depot.

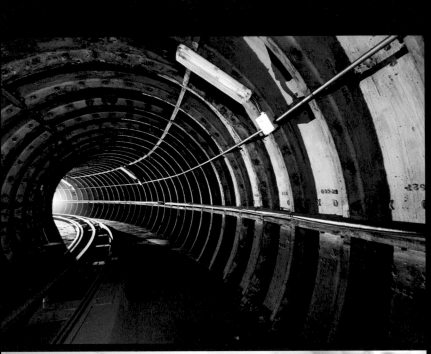

◄ The cambered trackbed of the Mail Rail running tunnels allowed the trains to hurtle through here all day long at upwards of 40mph.

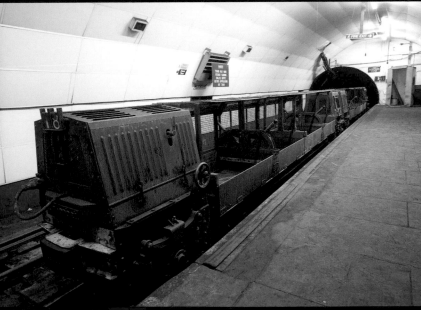

◄ A red Post Office mini york sits stabled in a platform in the underground Mail Rail. The mini yorks used to move post across the city.

► A stabled mini york on the Mail Rail at the Museum Street station.

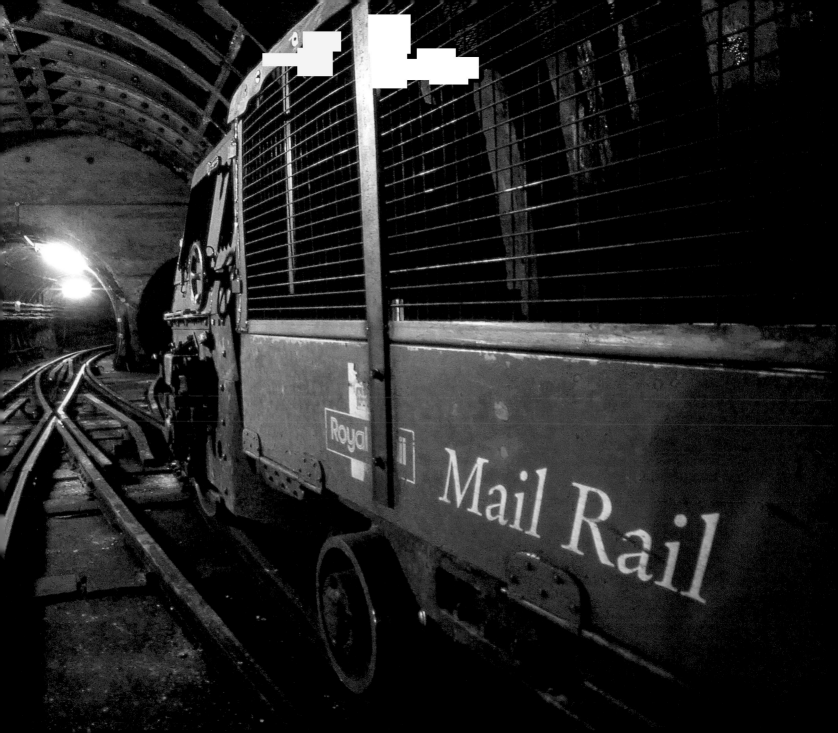

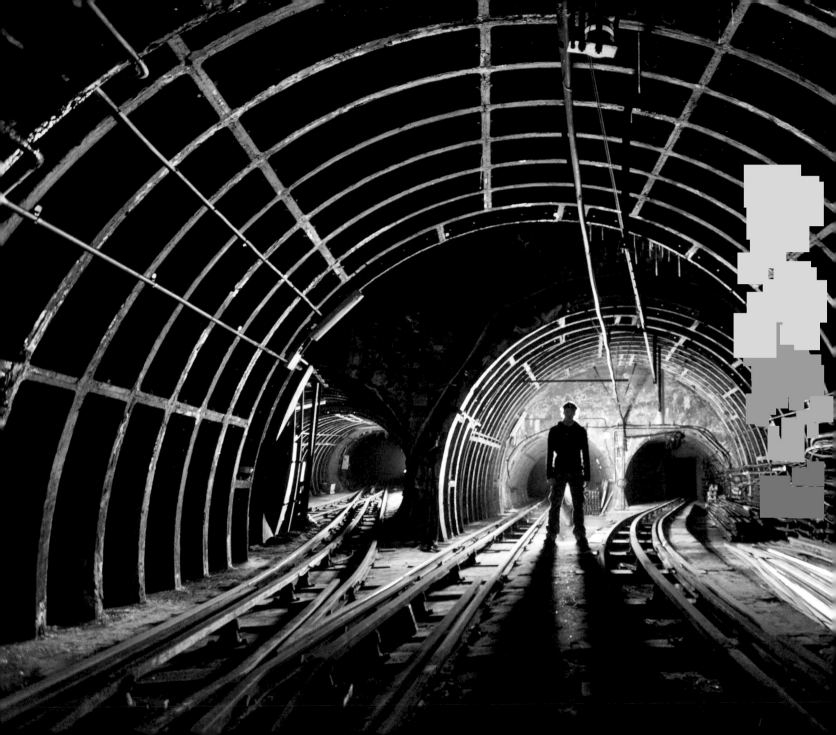

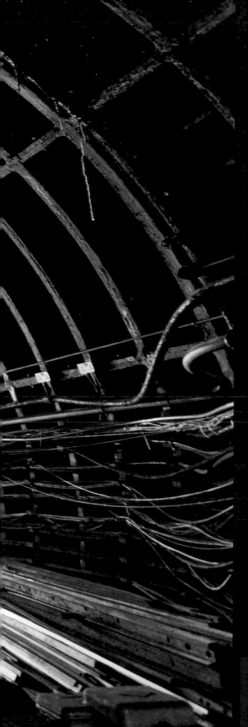

WALKING MILES OF
EMPTY TUNNELS,
WE FOUND IT DIFFICULT
TO COMPREHEND
THE RENT PER SQUARE
FOOT WE PAID FOR
OUR FLATS.

◀ A three-way junction on the Mail Rail.

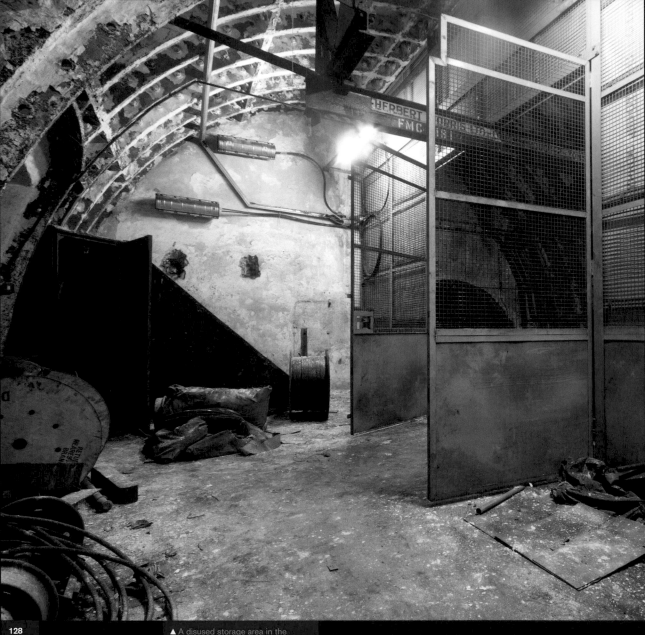

▲ A disused storage area in the

▲ The Mail Rail resembles a smaller version of the tube system in many ways, not least in its zero-clearance tunnels.

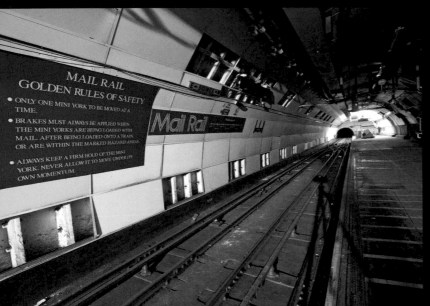

MAIL RAIL
GOLDEN RULES OF SAFETY

● ONLY ONE MINI YORK TO BE MOVED AT A
TIME.

● BRAKES MUST ALWAYS BE APPLIED WHEN
THE MINI YORKS ARE BEING LOADED WITH
MAIL. AFTER BEING LOADED ONTO A TRAIN
OR ARE WITHIN THE MARKED HAZARD AREAS.

● ALWAYS KEEP A FIRM HOLD OF THE MINI
YORK. NEVER ALLOW IT TO MOVE UNDER ITS
OWN MOMENTUM.

◀ The Mail Rail, a 6.5 mile system,
deeper than the tube, built in 1927 by
the General Post Office to transport
post across the city from Whitechapel
to Paddington.

▶ One of the best-preserved stations
on the Mail Rail.

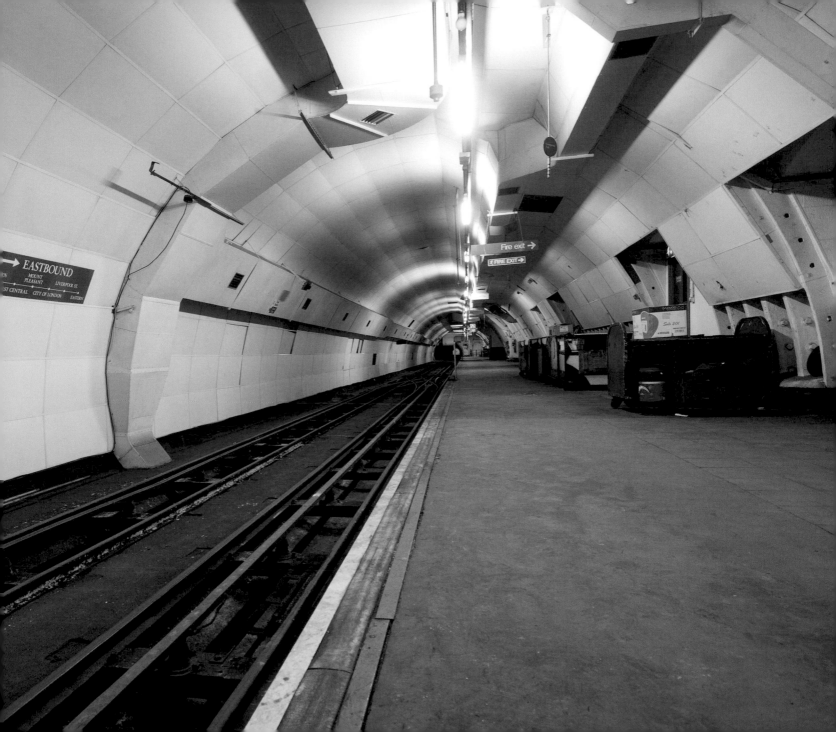

THE TUNNELS OF THE DEEP LEVEL WERE UNLIKE ANYTHING WE'D EXPERIENCED BEFORE.

▶ Ventilation ducts snaking around the characteristic arciform tunnels of the Clapham North deep-level shelter.

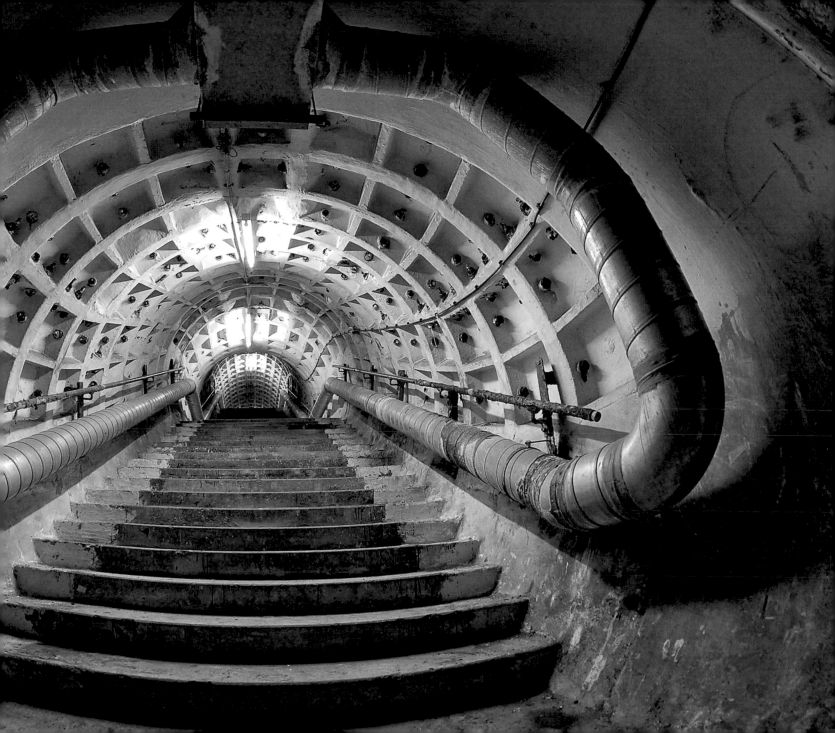

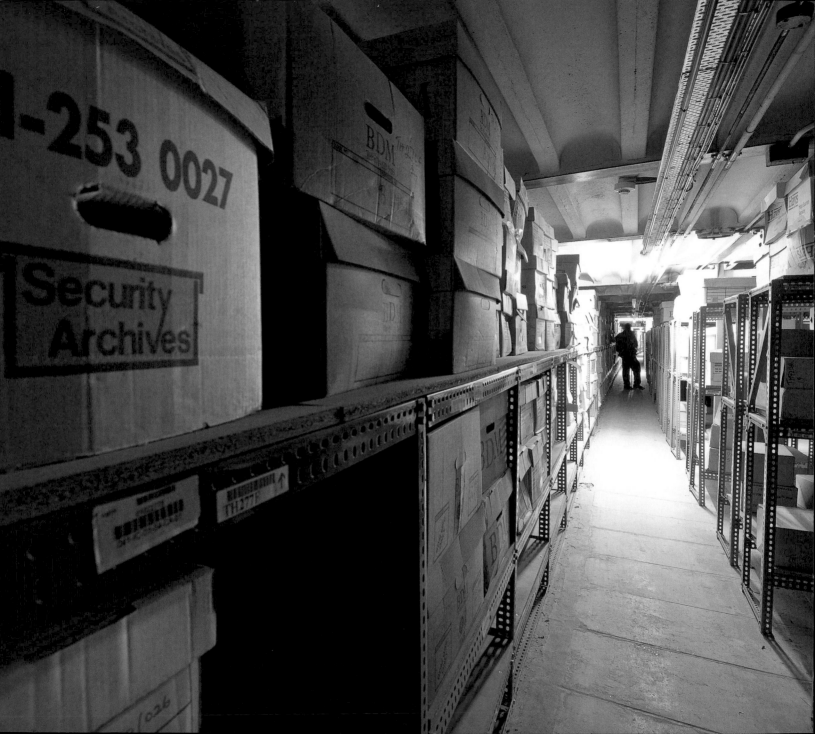

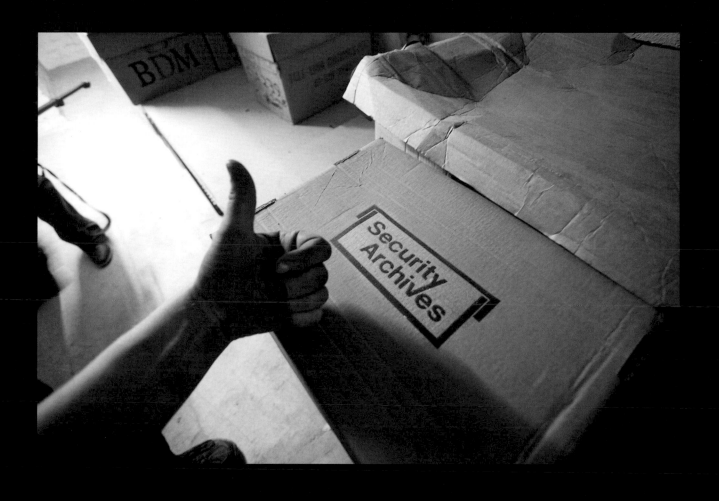

◀ Many of the deep-level shelters have been repurposed as sites for secure document storage.

▲ Secure file storage successfully infiltrated.

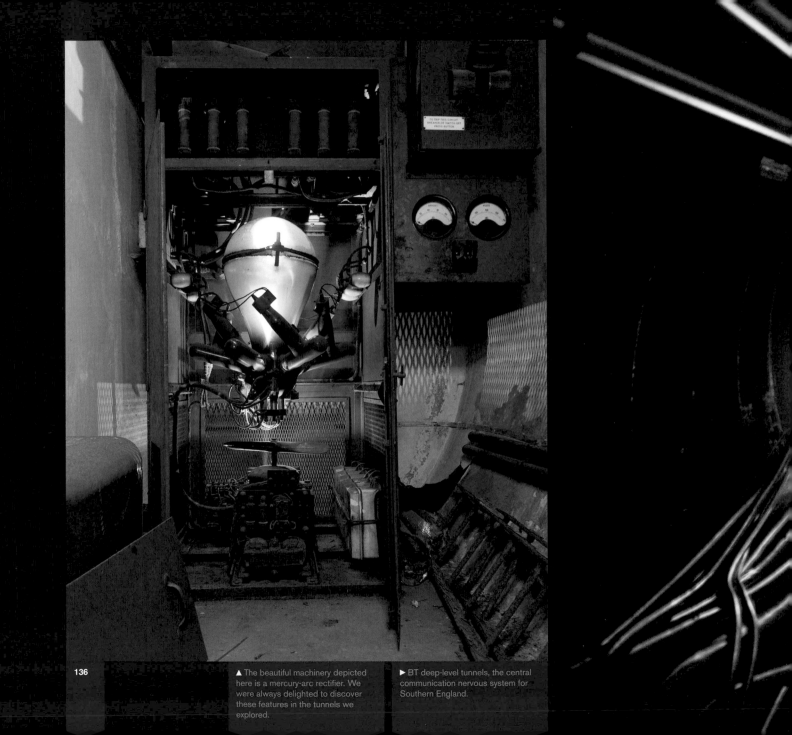

▲ The beautiful machinery depicted here is a mercury-arc rectifier. We were always delighted to discover these features in the tunnels we explored.

▶ BT deep-level tunnels, the central communication nervous system for Southern England.

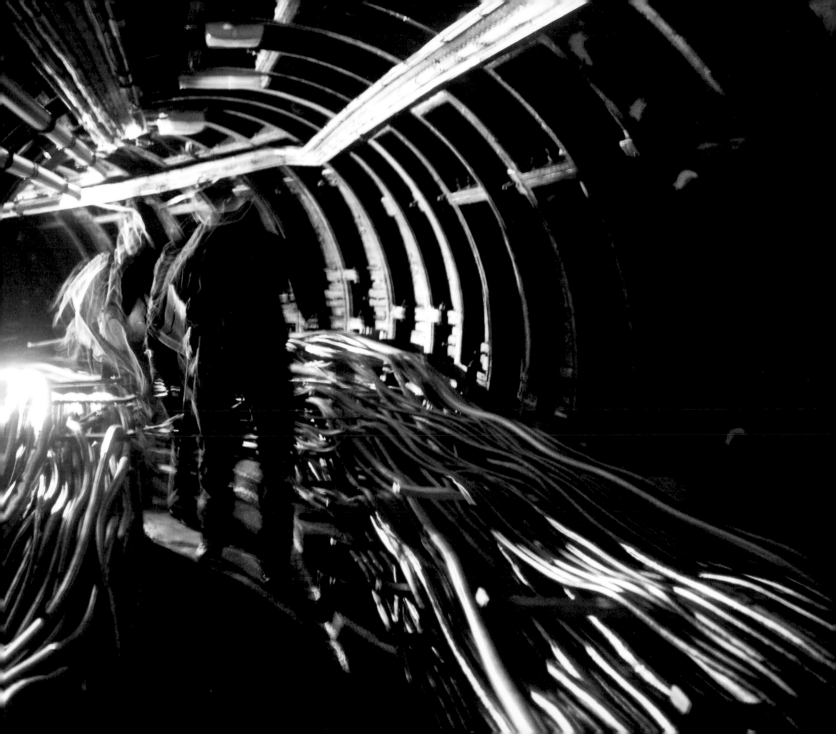

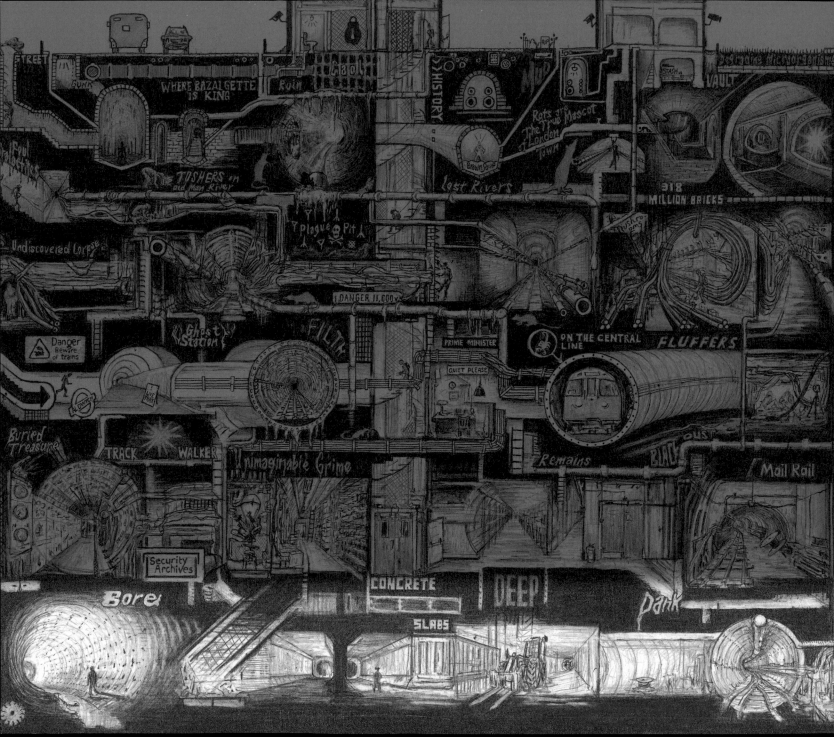

FRESH BORE

London is a city of change. Over the last few years it has trembled with transformation brought on by fresh architectural projects – an anamnesis of Victorian upheaval. To us, the variety and richness of the city were being shaped, now more than ever, by a dialogue between its storied past and a future it was perpetually performing – a spectacle striating dual axes, as the proliferation of corporate skyscrapers and high-income high-rises mirrored an equally ambitious range of tunnelling projects taking place beneath the streets. As the centre of the government, financial, media and technology industries attracted more people into its ambit, existing infrastructure was burdened by gathering bodies. So for each of the major systems we had previously explored – drainage, power, transit – it seemed there was a contemporary analogue under construction that would update and improve the existing networks that have served the city since the time of Bazalgette and Brunel.

With the explorations of the tube and deep-level structures still fresh, it was only a matter of time until we applied what we had learned in the pursuit of this new spatial knowledge, unravelling the mysteries of contemporary excavation. Research became less an antiquarian historicism and more simply a matter of keeping abreast of current affairs – every newspaper opened, TV switched on or site clicked seemed to reveal the completion of fresh sink shafts and announce the arrival of fleets of tunnel-boring machines. In the midst of this media coverage, many of the most prominent projects began opening their doors to the public during architectural or engineering-focused open days. Our seemingly esoteric enthusiasm for subterranean infrastructure had always been reflected back through encouraging and supportive public comments. With this new phase of unprecedented transparency offering Londoners the opportunity to learn of, be informed about and experience these places for themselves, albeit with guides, we felt our practice, for so long shrouded in the secrecy of a private discourse, occulted from the general ebb and flow of London life, had been validated by, ironically, corporate public responsibility.

Yet for all this, old habits die hard, and the path we had carved over the years inevitably drew us in again – we had to experience these changes on our own terms. However, 24-hour operations, state-of-the-art surveillance and security backed by colossal operating budgets, together with the high-profile nature of these excavations, meant that our infiltrations would be as challenging as any deep-level tube mission. More than ever, the game was about patience, timing, exacting research, observation and a hard-earned intuition for knowing precisely at which moment to cross a boundary. There was no doubt, upon finally doing so, that the stakes had again been raised. While it was exciting for us, as self-confessed rail geeks, to find operational narrow-gauge rolling stock stabled in some of these tunnels, its presence weighed on our minds as we ventured forward down the tracks, constantly aware that at any moment, if our timing was wrong, we could very well meet one of these beasts, laden with workers and strapped with tonnes of tunnel sections, hurtling towards us at 40mph. Given this mental pressure, the (not infrequent) sounds of ventilation plants and automated pumps suddenly jerking into life inspired incessant anxiety.

The atmosphere we encountered inside the Crossrail construction, new sewer networks and National Grid excavations, deeper than anything that had ever existed in London, was wholly new, in historical terms, but perhaps even more poignantly in subjective terms. The aesthetic phenomena of the sewer, utility, tube and deep-level tunnels, so often marked by Victorian ornament, cold-war enamelling and years of accumulated grime, were juxtaposed with new landscapes of scintillating halogen lights, playing gorgeously over perfectly smooth surfaces in unfinished concrete systems. If our previous exploits could be likened to a kind of old-fashioned Goonies adventure tale, these new discoveries suggested a breaking-through of old paradigms, as we suddenly found ourselves in the domain of science fiction. The buzzing of the lights, the gauzy clouds and patinas of newly minted cement dust and the perpetual throb of bleeding-edge machinery all moved together to create the impression of an otherworldly and endlessly fascinating realm of the futuristic. It is in this context we leave this story – as unfinished as our explorations.

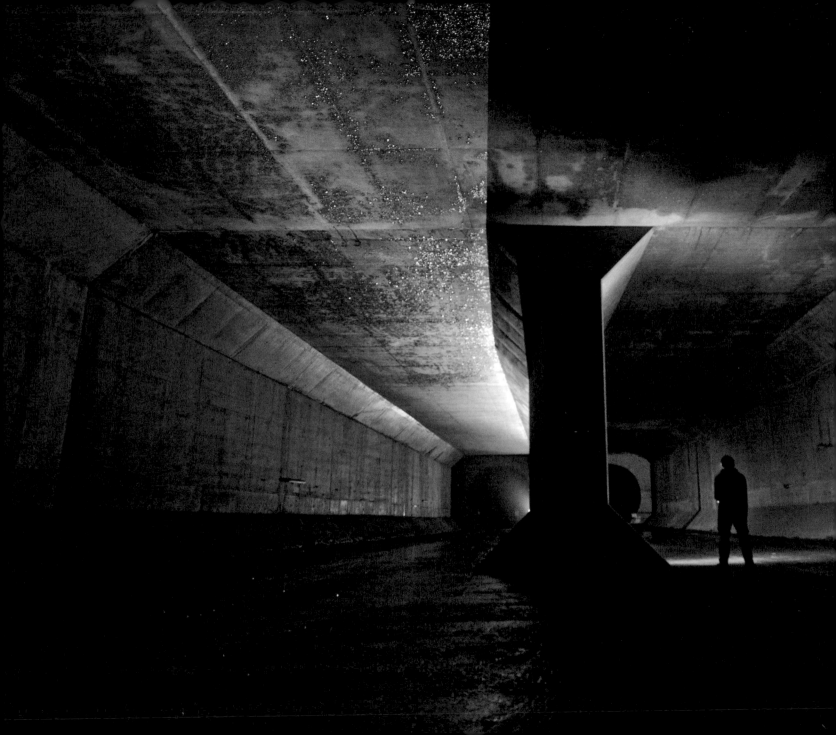

◀ The Thameslink Canal Tunnels will eventually carry national train services into the London Underground for more efficient passenger transfers.

▶ Variation between tunnelling techniques in the new connecting tunnels linking national to London Underground services.

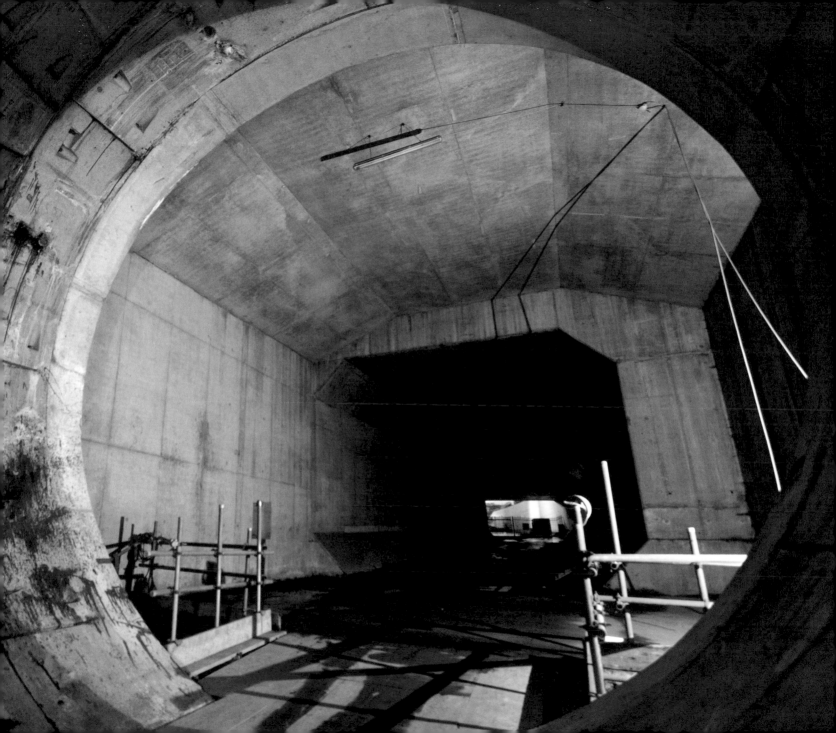

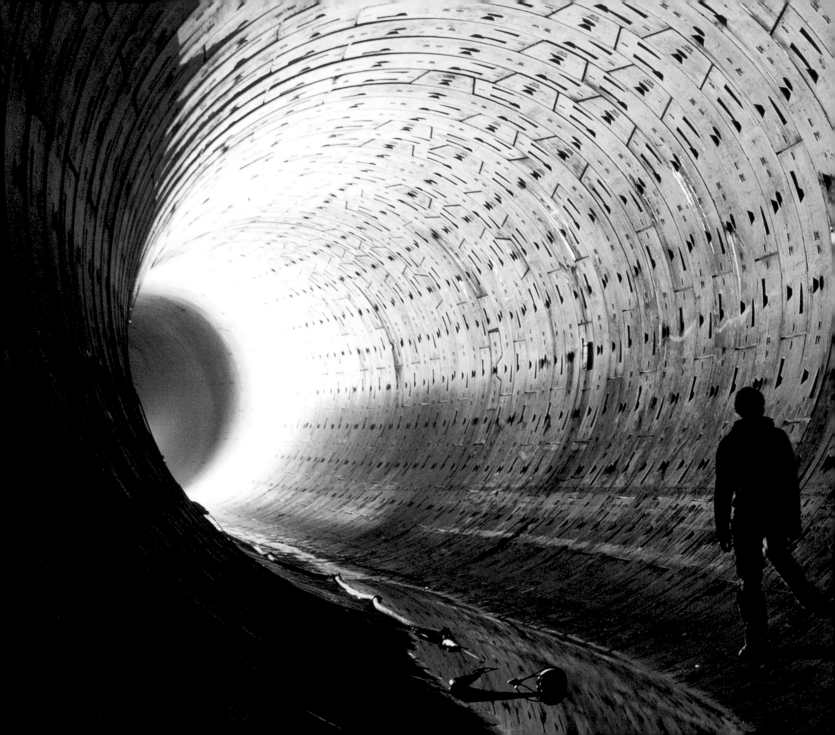

◄ We were awestruck by the scale of these new tunnels.

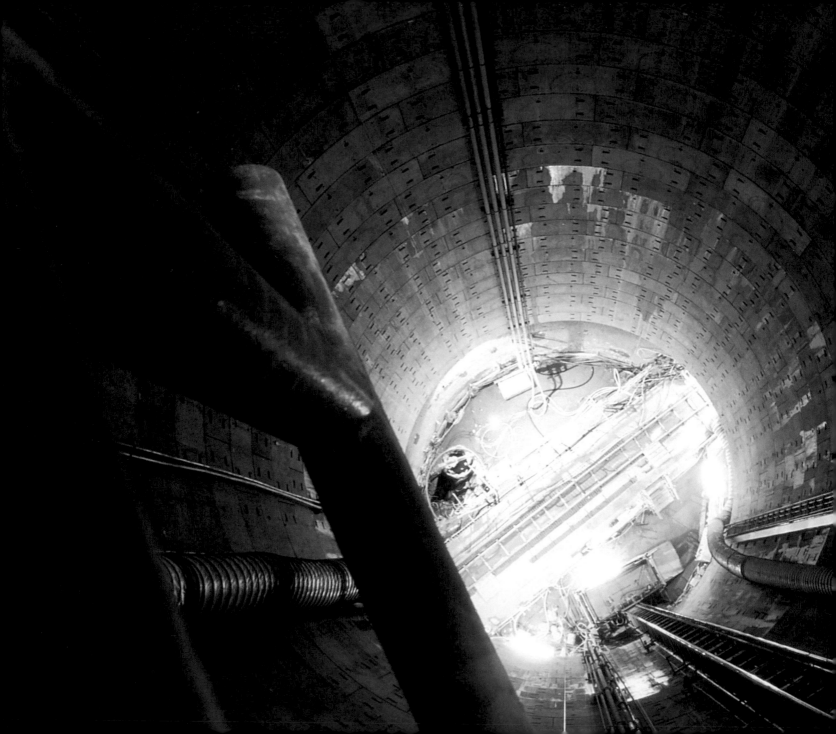

24-HOUR OPERATIONS, STATE-OF-THE-ART SURVEILLANCE AND SECURITY BACKED BY COLOSSAL OPERATING BUDGETS, TOGETHER WITH THE HIGH-PROFILE NATURE OF THESE EXCAVATIONS, MEANT THAT OUR INFILTRATIONS WOULD BE AS CHALLENGING AS ANY DEEP-LEVEL TUBE MISSION.

◀ When we tentatively explored the National Grid excavations we discovered we could access them by free-climbing down a 12-storey box-hoist.

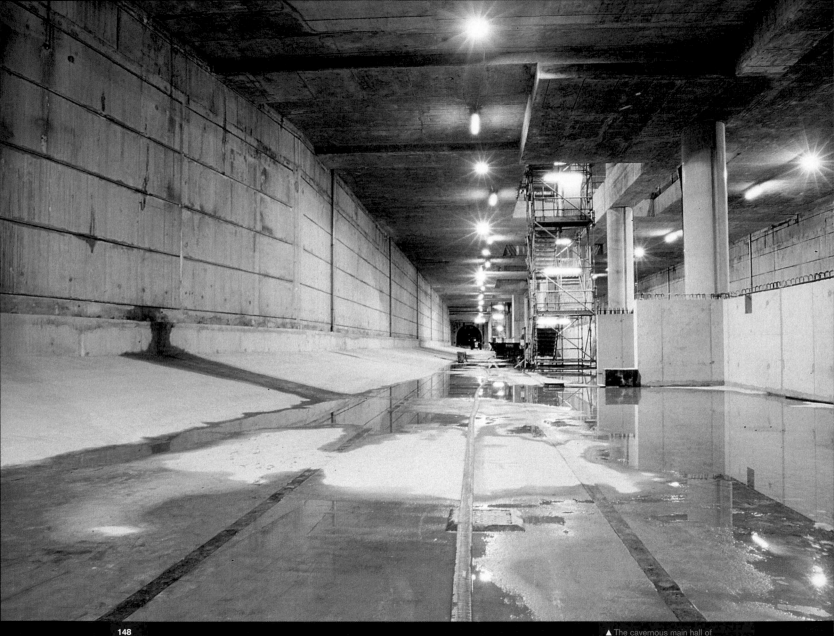

▲ The cavernous main hall of

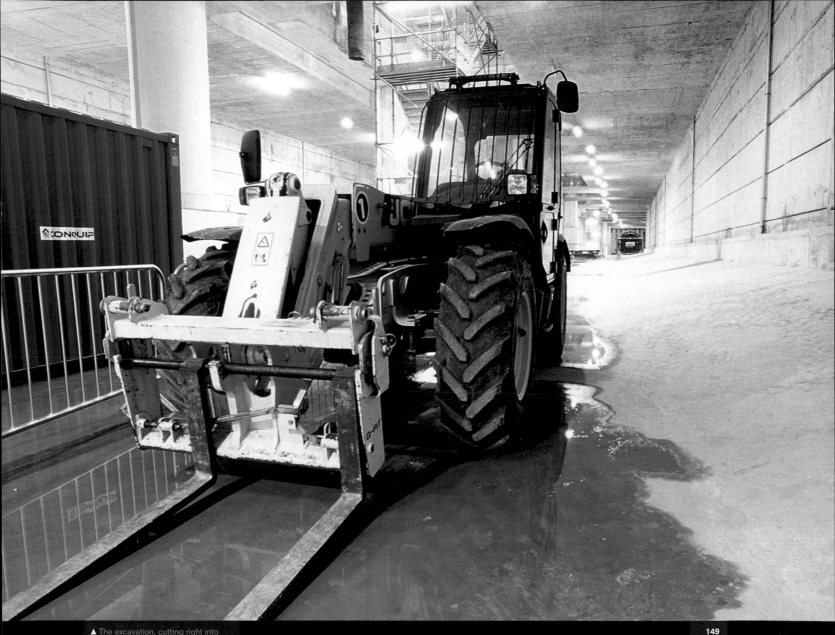

▲ The excavation, cutting right into

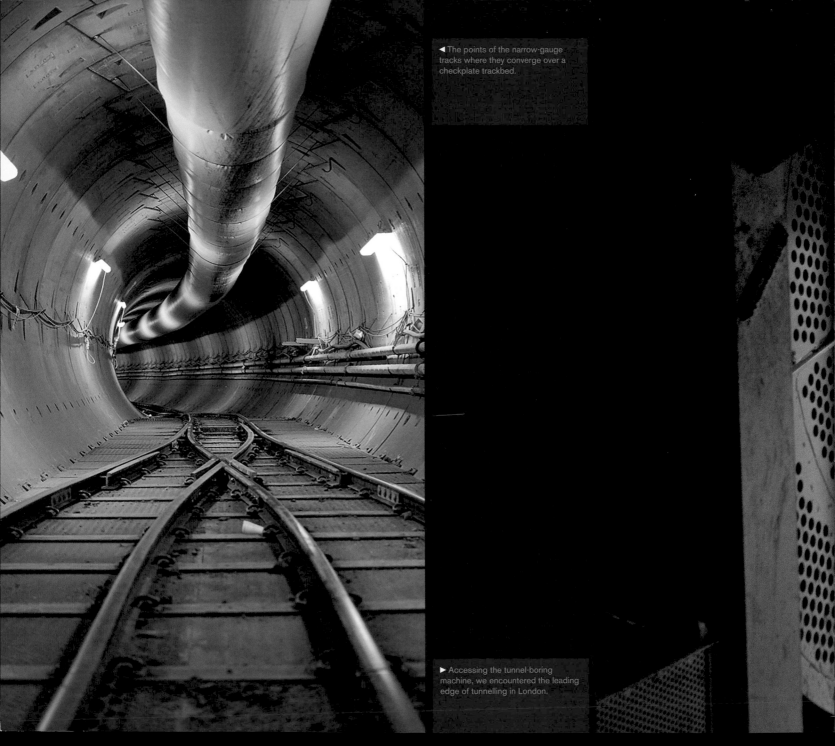

◄ The points of the narrow-gauge tracks where they converge over a checkplate trackbed.

► Accessing the tunnel-boring machine, we encountered the leading edge of tunnelling in London.

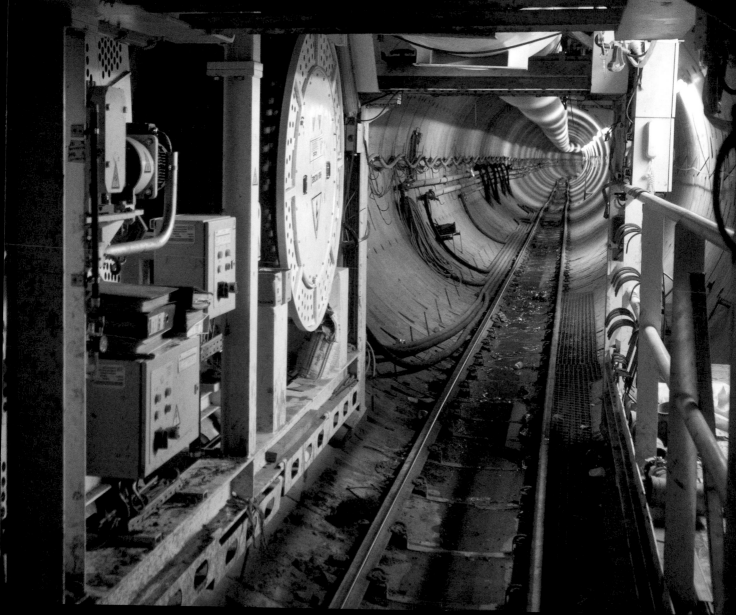

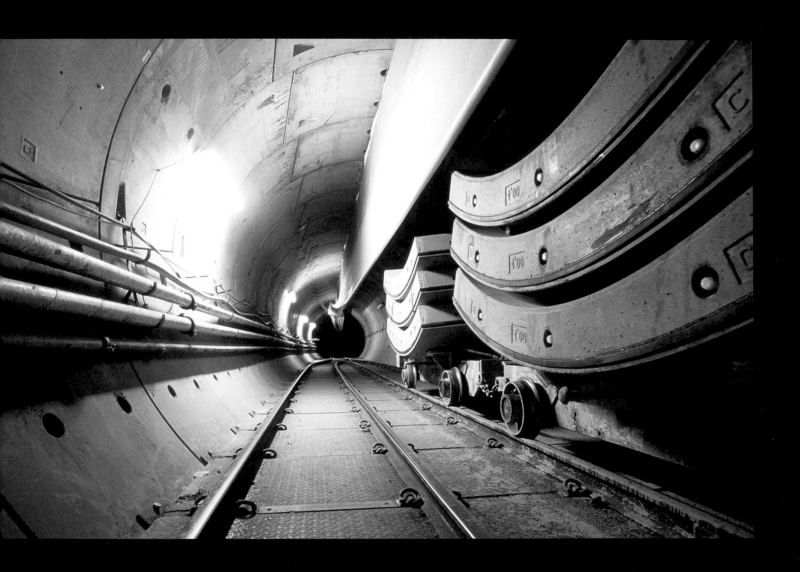

▲ Concrete tunnel sections loaded up and ready to be pulled into the emerging tunnel cavity.

▶ The narrow-gauge trains that carry workers and tunnel sections into the tunnel-face work sites deep underground.

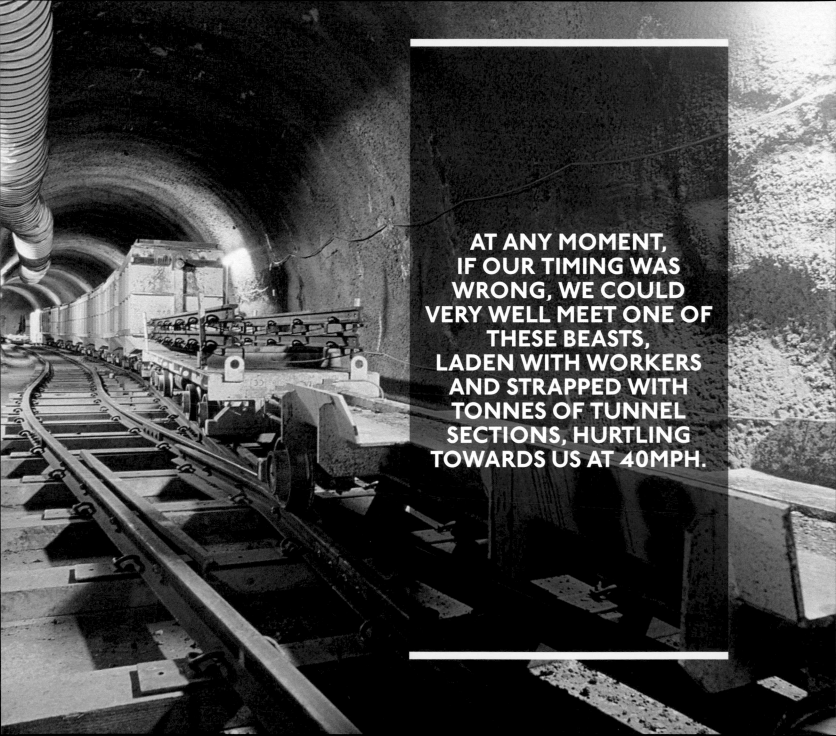

AT ANY MOMENT,
IF OUR TIMING WAS
WRONG, WE COULD
VERY WELL MEET ONE OF
THESE BEASTS,
LADEN WITH WORKERS
AND STRAPPED WITH
TONNES OF TUNNEL
SECTIONS, HURTLING
TOWARDS US AT 40MPH.

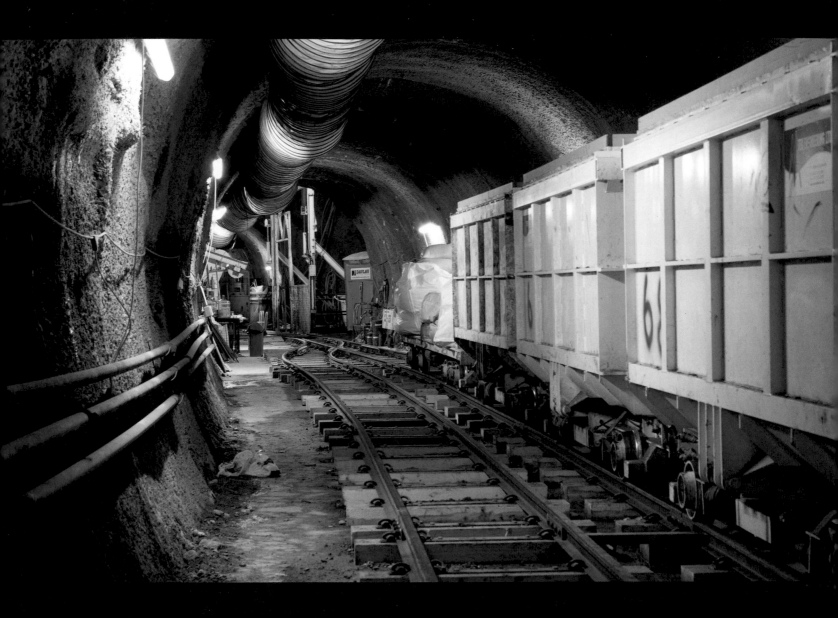

▲ One of the tunnels' many mainshafts offering space for mustering, stabling and storage for tunnel operations.

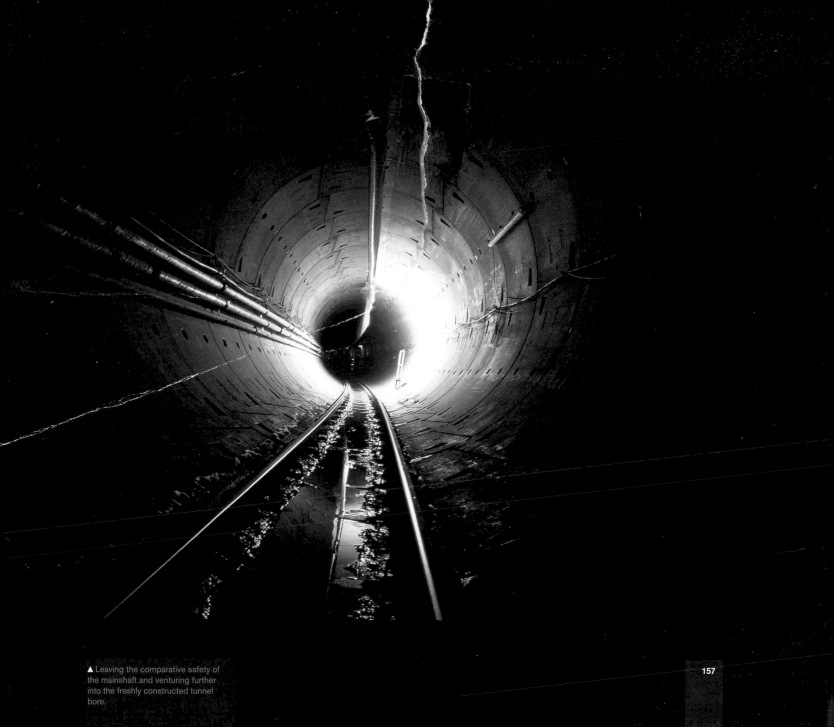

▲ Leaving the comparative safety of the mainshaft and venturing further into the freshly constructed tunnel bore.

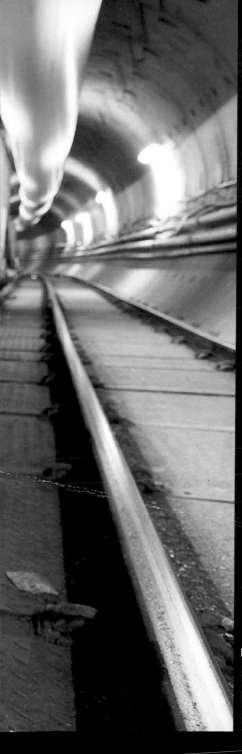

THE BUZZING OF THE LIGHTS,
THE GAUZY CLOUDS AND
PATINAS OF NEWLY MINTED
CEMENT DUST AND THE PERPETUAL
THROB OF BLEEDING-EDGE
MACHINERY ALL MOVED TOGETHER
TO CREATE THE IMPRESSION
OF AN OTHERWORLDLY
AND ENDLESSLY FASCINATING
REALM OF THE FUTURISTIC.

◄ A small reminder of British ingenuity
and ambition, and of London's
position in the vanguard of change
and development.

Front cover: residu.es
Back cover: Bradley L. Garrett
Images selected by Luke Bishop, Scott Cadman, Guy S. Crécy,
Bradley L. Garrett and Dan Salisbury
Endpapers: from Stephen Walter's 'London Subterranea',
courtesy of Stephen Walter & TAG Fine Arts
Illustration: 'Subterranean Playground' by Stephen Walter,
courtesy of Stephen Walter

Prestel Verlag, Munich
A member of Verlagsgruppe Random House GmbH

Prestel Verlag
Neumarkter Strasse 28
81673 Munich
Tel. +49 (0)89 4136-0
Fax +49 (0)89 4136-2335

www.prestel.de

Prestel Publishing Ltd.
14–17 Wells Street
London W1T 3PD
Tel. +44 (0)20 7323-5004
Fax +44 (0)20 7323-0271

Prestel Publishing
900 Broadway, Suite 603
New York, NY 10003
Tel. +1 (212) 995-2720
Fax +1 (212) 995-2733

www.prestel.com

Library of Congress Control Number: 2014936645

British Library Cataloguing-in-Publication Data: a catalogue record for this
book is available from the British Library; Deutsche Nationalbibliothek holds
a record of this publication in the Deutsche Nationalbibliografie; detailed
bibliographical data can be found under: http://dnb.d-nb.de

Prestel books are available worldwide. Please contact your nearest
bookseller or one of the above addresses for information concerning your
local distributor.

Editorial direction: Ali Gitlow

Editorial assistance: Lincoln Dexter

Copyediting: Sebastian Manley

Design and layout: The Studio of Williamson Curran

Production: Friederike Schirge

Origination: Reproline Mediateam

Printing and binding: Neografia, a.s.

Printed in Slovakia
Verlagsgruppe Random House FSC®-DEU-0100
The FSC®-certified paper Profisilk has been supplied by Igepa.

ISBN 978-3-7913-4945-9

FSC
www.fsc.org
MIX
Paper from
responsible sources
FSC® C020353